MW01097561

Barbie™

THE OFFICIAL
COCKTAIL BOOK

Barbie™

THE OFFICIAL
COCKTAIL BOOK

50
DREAMY
RECIPES
FOR
INSPIRED
ENTERTAINING

GINNY LANDT

Running Press

PHILADELPHIA

BARBIE™ and associated trademarks and trade dress are owned by, and used under license from, Mattel.

©2025 Mattel.

Hachette Book Group supports the right to free expression and the value of copyright. The purpose of copyright is to encourage writers and artists to produce the creative works that enrich our culture.

The scanning, uploading, and distribution of this book without permission is a theft of the author's intellectual property. If you would like permission to use material from the book (other than for review purposes), please contact permissions@hbgusa.com. Thank you for your support of the author's rights.

Running Press
Hachette Book Group
1290 Avenue of the Americas, New York, NY 10104
www.runningpress.com
@Running_Press

First Edition: May 2025

Published by Running Press, an imprint of Hachette Book Group, Inc. The Running Press name and logo are trademarks of Hachette Book Group, Inc.

Running Press books may be purchased in bulk for business, educational, or promotional use. For more information, please contact your local bookseller or the Hachette Book Group Special Markets Department at Special.Markets@hbgusa.com.

The publisher is not responsible for websites (or their content) that are not owned by the publisher.

Photography and text by Ginny Landt
Print book cover and interior design by Justine Kelley

Library of Congress Cataloging-in-Publication Data
Names: Landt, Ginny, author.
Title: The official Barbie cocktail book: 50 dreamy recipes for inspired entertaining / Ginny Landt.
Description: First edition. | Philadelphia: Running Press, 2025. | Includes index.
Identifiers: LCCN 2024042341 | ISBN 9780762488827 (hardcover) | ISBN 9780762488834 (ebook)
Subjects: LCSH: Cocktails. | LCGFT: Cookbooks.
Classification: LCC TX951 .L324 2025 | DDC 641.87/4—dc23/eng/20240923
LC record available at https://lccn.loc.gov/2024042341

ISBNs: 978-0-7624-8882-7 (hardcover); 978-0-7624-8883-4 (ebook)

Printed in Italy

Elcograf

10 9 8 7 6 5 4 3 2 1

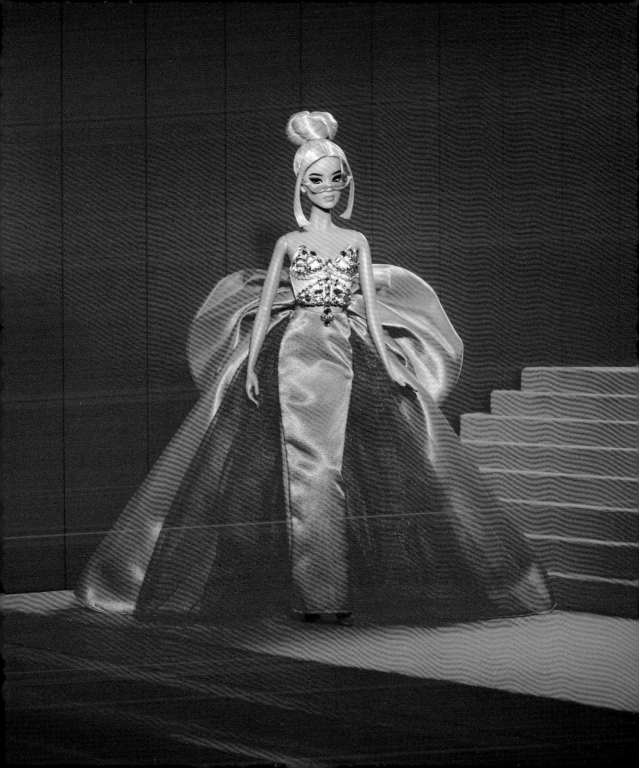

Contents

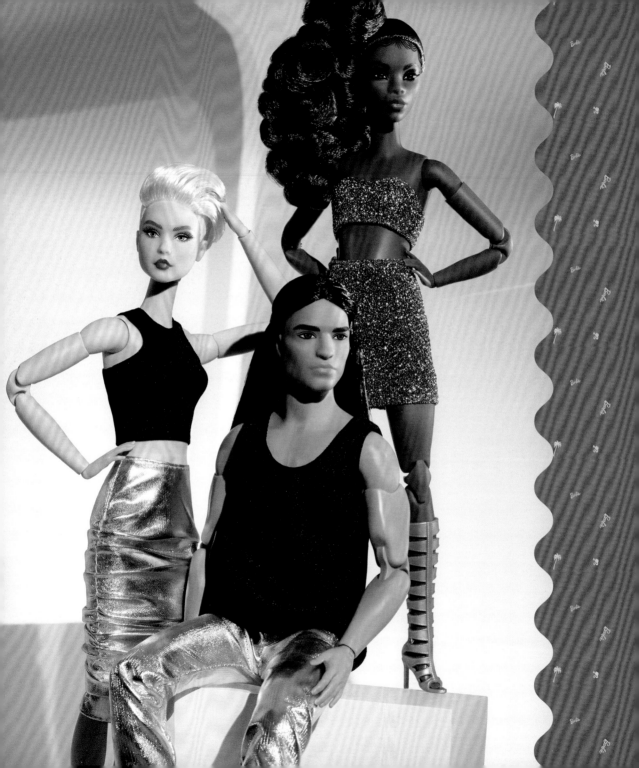

INTRODUCTION

Welcome to *Barbie: The Official Cocktail Book*! The cocktails and mocktails in this book are all inspired by Barbie—her fashions, stories, pastimes, and friends. Use this book to spritz up your next gathering, celebrate your accomplishments, and cherish your relationships. These recipes are divided into five chapters, but you can start anywhere you would like—there's something for everyone! Barbie reminds us to choose our own path, try new things, and share with friends along the way.

THE STORY BEHIND THE ICON

When Barbie came onto the scene in her now instantly recognizable black-and-white striped swimsuit and fierce white-framed sunglasses, few anticipated the worldwide sensation and trailblazer that Barbie would become, inspiring children and adults everywhere.

The creator of Barbie, Ruth Handler, observed that the dolls available for girls were usually babies or children themselves, but they were often used in make-believe games to role-play grown-up careers and roles in society. Handler saw the potential in creating a doll with a grown-up look specifically designed for girls. In her own words, "My whole philosophy was that through the doll, a little girl could be anything she wanted to be."

Handler wanted to show kids that they could aspire to any career they wanted, that the world is limitless for them. So she created a doll with adult features and aspirations: Barbie (named after her daughter Barbara). The first Barbie debuted on March 9, 1959—but no major toy retailers were interested.

After all, why would children want to play with a doll that looked like an adult?

Luckily, Handler had a plan to sell her creation directly to consumers. Two-minute black-and-white commercials for Barbie were shown on television during the most popular kids' programming—at this time toy commercials were virtually unheard of. But it worked, and when children saw the ads, they begged their parents to buy her for them. Over 300,000 of the dolls sold in the first year.

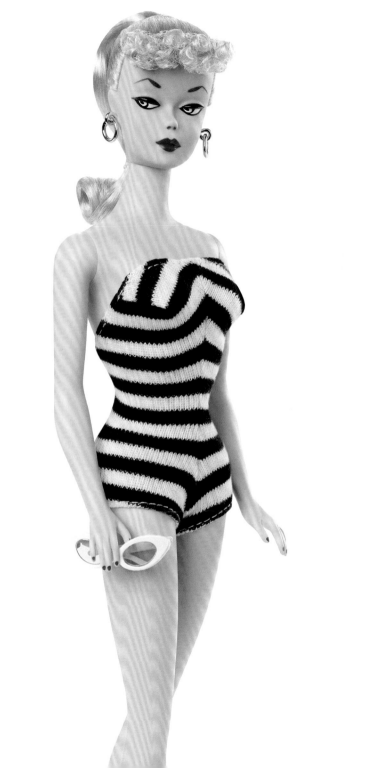

Over the years, Barbie grew to develop a storyline, filled with adventures and new friendships. The launch of her first friend in 1961 continues to be her most iconic friend of all—Ken! In 1968, Mattel launched her friend Christie, a Black doll with short, curly hair. Latina doll Teresa was launched in 1988 as a Malibu neighbor and friend to Barbie. As Barbie flourished with dazzling new careers and friends, so did her world, incorporating locations like the Dream-House—an icon of its own accord.

In 1960, Barbie donned a pinstripe power suit as a woman in business. Over the years, she would go on to defy expectations time and time again, entering the workforce in careers where women were seldom seen. In fact, Barbie became an astronaut four years before Neil Armstrong walked on the moon. All told she has had over 250 careers (and counting!), including CEO, rock star, computer engineer, and paleontologist—she's even run for president on several occasions.

Staying true to the guiding principle and Handler's philosophy, Barbie is now available in multiple body types, eye shapes and colors, skin tones, hair types, disabilities, and more, to represent all

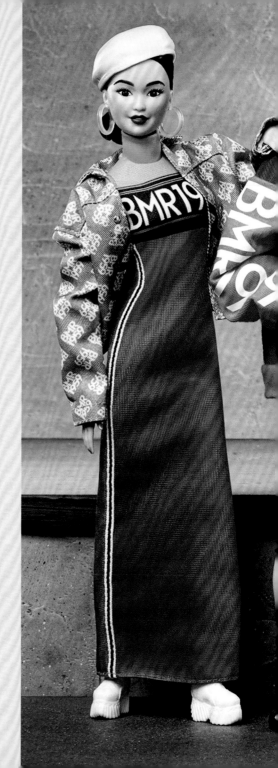

types of kids, and to affirm that anyone and everyone can aspire to dream and live big.

Despite its original launch as a toy for girls, Barbie has also become an inspiration for adults, often representing the progress women have made and symbolizing that there are no limits to what they can be. The inclusivity, the couture, the inspirational careers—Barbie is a wonderful way for adults to express their own creativity and visualize their dreams.

In the following chapters, you'll find everything you need to shake, stir, and create fifty different Barbie-inspired beverages—including how to design one yourself.

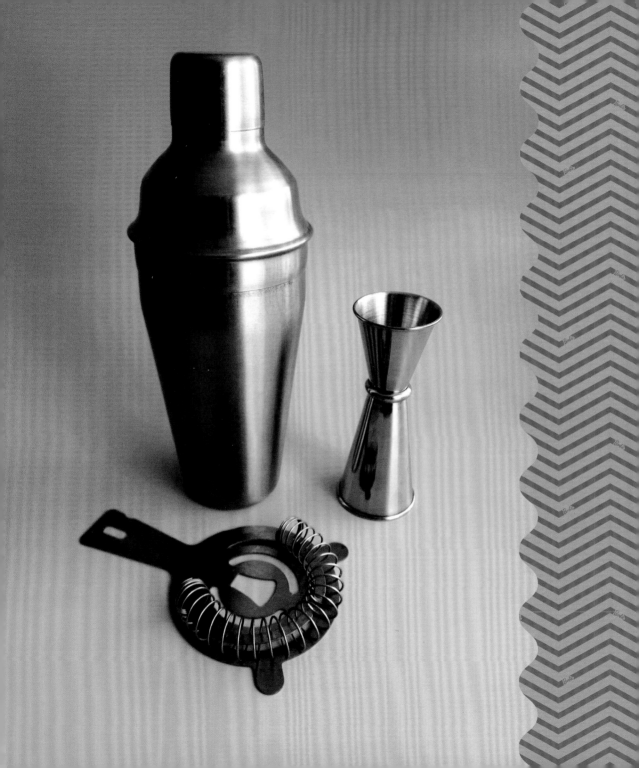

COCKTAIL BASICS

Cocktails and mocktails can be fun and versatile ways to express your creativity. The recipes that follow are flexible: they can be adjusted to fit what works for *you*. Don't be afraid to make changes, whether by increasing the amount of sweetness or tartness, switching out one spirit for another, or removing spirits altogether. Be true to your own tastes, and feel free to customize all of these drinks to suit the preferences of you and your friends. Remember to drink responsibly!

EQUIPMENT

GLASSWARE

Although more types exist, in this book there are three main types of glassware used. Even within these categories, a range of sizes is available. When possible, chill glassware in the fridge before using to keep the drink cool longer.

COLLINS OR HIGHBALL GLASS

This slim, tall glass is for drinks served over ice. A pint glass can be used as well.

COUPE

This stemmed glass with a shallow saucer is ideal for shaken or stirred drinks served straight up (without ice). A martini glass or small wineglass can also be used.

ROCKS OR OLD-FASHIONED GLASS

This short, wide glass is ideal for shaken drinks served over ice or stirred drinks served with a large ice cube.

Other glasses that may be used are mugs, champagne flutes, or wineglasses.

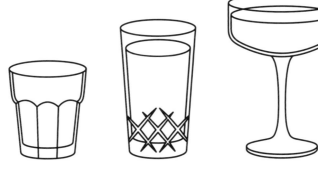

COCKTAIL SHAKER

Used for shaken cocktails, a basic cocktail shaker may have a metal lid and base or come with a strainer built into the lid as well. A large mason jar can also be used in place of a cocktail shaker.

MIXING GLASS AND BARSPOON

For stirred drinks, a large mixing glass (a pint glass can also be used) and barspoon are used to combine and chill cocktails; stirring does not introduce as much air as shaking. Barspoons have an elongated handle for easier stirring.

STRAINER

Strainers are used to pour the drink from your shaker or mixing glass into the drinking vessel, leaving the mixing ice behind. Hawthorne strainers are the most common strainer type found in bars and contain a metal coil that prevents pulp and ice from being poured into the final cocktail. A fine mesh strainer can also be used for shaken cocktails as it will prevent the smallest shards of ice from making it into the final drink.

JIGGER AND MEASURING SPOONS

Used for measuring ingredients, jiggers come in several sizes for different measurements. For the most versatility, use a small liquid measuring cup or graduated jigger. Some ingredients may be measured using measuring cups, tablespoons, and teaspoons.

MUDDLER

Use this tool to smash fruit or herbs in the bottom of a cocktail shaker or cocktail glass to release juices or flavor oils. If you don't have a muddler, you can use a wooden spoon as a substitute.

PEELER

Although many drinks can be garnished with a slice or wedge of citrus, a vegetable peeler can be used to remove the peel from lemon, lime, grapefruit, or orange to curl and shape the peel. Try to remove the majority of the pith from the peel (the white flesh underneath it) so that it can be more easily shaped.

A few other items may be used that you likely already have in your kitchen, such as a blender for frozen drinks, saucepan for preparing syrups, and cutting board for garnishes.

SPIRITS AND NONALCOHOLIC OPTIONS

The alcoholic component of cocktails (often called the base) can be made up of liquor, liqueur, and even wine, beer, or cider.

While there are more liquors available than those listed below, these are the six you'll find in the recipes that follow:

VODKA

Distilled from grains, potatoes, and many other materials, the resulting spirit has a very neutral flavor.

GIN

Typically distilled from grains, gin gets its unique flavor from added botanicals like juniper, citrus, and other herbs, spices, and flowers. Dry gin will have the strongest juniper flavor, while American gin will have a much lighter flavor and may be preferable if you're not fond of dry gin's signature piney taste.

RUM

Distilled from sugar or molasses, rum is often aged in wood casks. Light rum (also known as white or silver rum) is the most common and has the most delicate flavor. Gold rums and aged rums take on a golden color from the barrels in which they are aged, as well as a more complex flavor. These can vary greatly depending on how long they are aged, the barrel, the quality of the sugarcane used, and the region they are from.

TEQUILA

Distilled from the agave plant and produced in Mexico, tequila comes in several grades, the ones most commonly used for cocktails being reposado tequila, which is aged in oak casks for at least two months, and blanco tequila, also known as silver or white tequila, which may not have been aged at all. For the cocktails in this book, you can use either variation.

WHISKEY

Distilled from malted grains like barley, rye, corn, and wheat, whiskey has many different styles, with bourbon, rye, and Irish whiskey being the most versatile for use in cocktails.

PISCO

Originating in Peru, this liquor is distilled from fermented grape juice.

LIQUEURS

These sweetened and flavored spirits typically have a lower ABV (alcohol by volume) than the base spirits themselves. Some are very fruity, and some are bitter or herbal; all are great ingredients for adding flavor to cocktails.

INFUSIONS

One way to customize your drinks is to infuse the base spirit with tea, fruit, herbs, coffee, and more. Because these spirits contain a high percentage of alcohol, they will have a long shelf life. Spirits infused with tea, coffee, or dry herbs can be kept in a cool, dry cabinet, but keep infusions using fresh fruit in the fridge.

HIBISCUS-INFUSED GIN

1 hibiscus tea bag (or about
1 teaspoon loose-leaf hibiscus tea)

8 oz gin (your choice)

Add 1 hibiscus tea bag (or about 1 teaspoon of loose-leaf hibiscus tea) to a jar and top with 8 oz of gin. Allow to infuse for 15 to 20 minutes and remove the tea. Store in a closed container in a cool, dry cabinet or in the fridge.

BUTTERFLY PEA FLOWER–INFUSED GIN

2 tablespoons dried butterfly pea flowers

8 oz gin (your choice)

Add 2 tablespoons of dried butterfly pea flowers to a jar and top with 8 oz of gin. Allow to infuse for 1 hour and then strain the gin into a fresh jar. Store in a cool, dry cabinet or in the fridge. If you prefer not to make your own, butterfly pea flower–infused gin is also available in many liquor stores.

MAKE IT A MOCKTAIL!

Although some of the recipes included are mocktails, many of the cocktails also come with suggestions for removing the alcohol. For a simple substitution in cocktails that only contain a base spirit with no other liqueurs, swap the spirit with cooled tea or coconut water. Use unsweetened versions with no added flavors to keep the balance of the drink similar to the original. And if you want vivid colors in your drinks, use hibiscus or butterfly pea flower tea.

HIBISCUS TEA

Brew 1 hibiscus tea bag (or about 1 teaspoon of loose-leaf hibiscus tea) with 8 oz of hot water for about 5 minutes. Cool, and if not using immediately, store in the fridge for up to 1 week.

BUTTERFLY PEA FLOWER TEA

Brew 1 tablespoon of butterfly pea flowers with 8 oz of hot water for about 5 minutes. Cool, and if not using immediately, store in the fridge for up to 1 week.

You can also experiment with using other fruit juices in place of spirits, but as they may add more sweetness and tartness to the drink, the amounts of syrup and lemon or lime juice may need to be slightly lowered. For example, if you replace the base spirit with pineapple juice (which brings more sweetness and acidity than something like tea) and the recipe calls for ¾ oz of lemon juice and ¾ oz of simple syrup, try reducing them by ¼ oz to start. Another fun way to change up the drinks is to replace the spirits with seltzer, but in this case, add the seltzer *after* shaking or stirring and straining the rest of the ingredients.

SYRUPS

For sweetness, most drinks use either simple syrup (a sugar and water mixture) or its different flavored versions. Simple syrup and flavored syrups are available premade at grocery stores and liquor stores, but they are easy to make at home as well.

SIMPLE SYRUP

8 oz water

1 cup sugar

Simple syrup is a staple for cocktail making, using equal parts sugar and water. Mix 8 oz of water with 1 cup of sugar (or scale accordingly). Heat on the stovetop or in the microwave, stirring occasionally, until the sugar has dissolved. Let cool, and store in a closed bottle or mason jar in the fridge for 2 to 3 weeks.

BROWN SUGAR SIMPLE SYRUP

8 oz water

1 cup brown sugar

Mix 8 oz of water with 1 cup of brown sugar (or scale accordingly). Heat on the stovetop or in the microwave, stirring occasionally, until the sugar has dissolved. Let cool, and store in a closed bottle or mason jar in the fridge for 2 to 3 weeks.

HIBISCUS SIMPLE SYRUP

1 hibiscus tea bag (or about 1 teaspoon loose-leaf hibiscus tea)

8 oz water

1 cup sugar

Brew hibiscus tea with 1 tea bag (or about 1 teaspoon of loose-leaf hibiscus tea) and 8 oz of hot water for about 5 minutes. While tea is still hot, add 1 cup of sugar and stir until dissolved. Try to find a hibiscus tea with no added flavors or sweeteners. Cool and store in the fridge for 2 to 3 weeks.

ROSE PETAL SIMPLE SYRUP

1 teaspoon food-grade dried rose petals

8 oz water

1 cup sugar

Brew rose petal tea with 1 teaspoon of food-grade dried rose petals and 8 oz of hot water for about 5 minutes. While tea is still hot, add 1 cup of sugar and stir until dissolved. Cool and store in the fridge for 2 to 3 weeks.

HONEY SYRUP

8 oz water

1 cup honey

Mix equal parts warm water and honey until combined, heating if necessary to mix. Store in the fridge for 2 to 3 weeks.

JALAPEÑO SIMPLE SYRUP

1 to 2 jalapeños, sliced

8 oz water

1 cup sugar

Add 1 to 2 sliced jalapeños (depending on how much spice you like!), 8 oz of water, and 1 cup of sugar to a saucepan. Heat, stirring occasionally, until the sugar is dissolved. Cool, strain out and discard the jalapeños, and store in the fridge for 2 to 3 weeks. Did your syrup turn out a little too spicy? Mix it with regular simple syrup to turn down the heat.

TOASTED MARSHMALLOW SYRUP

1 cup toasted marshmallows

8 oz water

1 cup sugar

Combine 1 cup of toasted marshmallows, 8 oz of water, and 1 cup of sugar in a saucepan. Heat on the stovetop, stirring occasionally, until both the sugar and marshmallows have dissolved. Let cool, and store in a closed container in the fridge for 2 to 3 weeks.

Many other syrups like grenadine (a pomegranate-based syrup), passion fruit syrup, and cream of coconut can be found at liquor stores and grocery stores.

OTHER INGREDIENTS

CITRUS

Lemon juice and lime juice are used to add acidity to many shaken cocktails. When possible, fresh-squeezed juice will provide the best flavor, but store-bought juice (either refrigerated or shelf-stable) is also an option. Lemon is typically used for cocktails containing whiskey, while lime is more frequently used for rum and tequila. Vodka and gin pair well with either lime or lemon, or a mix of the two juices.

BITTERS

These concentrated flavor extracts are made from infusing roots, herbs, spices, and botanicals in alcohol (although nonalcoholic bitters are also available). Used as a "seasoning" for cocktails, bitters can add complexity to drinks with just a few shakes of a bottle. Angostura aromatic bitters are commonly used both in drinks and to add a design to the foam on top of a cocktail.

EGGS

Egg whites can be used to change the texture of a shaken cocktail and add a great foam! A whole egg can be used in a "flip" cocktail for a creamy mouthfeel and custard-like flavor. If desired, these can be left out of recipes, though the final texture and flavor will differ. Additionally, egg whites can be replaced with aquafaba (the liquid from a can of chickpeas) for a similar foaming effect.

EDIBLE GLITTER

This can be purchased at craft stores or online. It's often available in a variety of colors. Shake or stir it into the cocktail and add more as desired.

OTHER INGREDIENTS

Milk, half and half, fresh fruit, coffee, tea, soda, and fruit or vegetable juices are other typical cocktail ingredients and are easy to find at the grocery store.

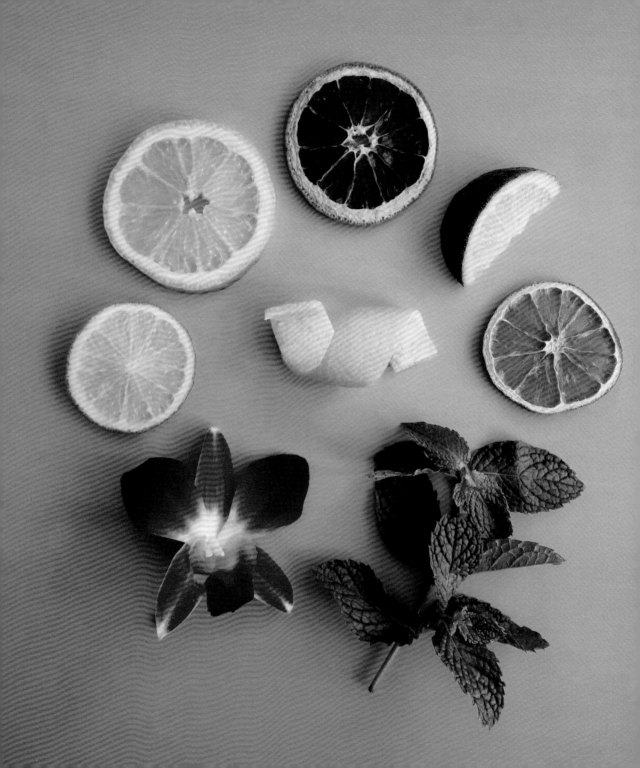

GARNISHES

People eat (and drink) with their eyes first, so a beautiful garnish is a creative way to add excitement to your beverage! You can float garnishes on top of a drink, balance them on the rim of the glass, or skewer them on a cocktail pick or toothpick.

CITRUS

A slice or wedge of lemon, lime, or orange is a classic. You can also use a peeler to carefully remove some of the peel and shape it into a curl with your fingers. For a more finished look, use kitchen shears to cut clean edges on your peel before curling. Dried citrus garnishes are also available.

EDIBLE FLOWERS, PLANTS, AND HERBS

Pineapple fronds and herbs like mint and rosemary are great classic garnishes. Flowers can be used as well, but be sure to use edible flowers like pansies, carnations, and hibiscus. Always check to make sure the plant is safe to consume if you intend to put it in the drink (leave it out unless you're completely certain). Flowers, petals, and herbs can be inserted in the ice of a cocktail after preparing (this works better with a drink filled with ice versus one served over a single cube), floated on top of a drink, attached to the side of the glass with a small clothespin (available at craft shops), or served alongside the cocktail.

SALT, SUGAR, AND SEASONINGS

Rimming a glass is a decorative touch that also adds a flavor element to a cocktail. Rub a slice of lemon or lime on the rim of a glass and then dip it into salt or sugar. Get creative by mixing seasonings like chili powder or cinnamon into your salt or sugar. For a more secure hold or for larger granulations, use a small piece of paper towel with a little simple syrup to apply a thin layer of syrup to the desired area of the glass before dipping in the salt or sugar. You can also use honey, frosting, or chocolate on the rim of the glass to adhere larger particulates, such as sprinkles and edible flowers.

MIXING TECHNIQUES

With a couple of exceptions (like hot or blended cocktails), the methods for assembling the cocktails in this book are primarily stirring or shaking. But which way to go? There's an easy rule of thumb: for drinks that contain lemon and lime, shake it. For cocktails without citrus (these tend to be strong, like a martini or an old-fashioned), stir over ice. Stirring introduces less air and will not break the ice into shards, allowing for a crystal-clear but chilled drink. Shaking quickly chills but also introduces air, so lots of tiny air bubbles will be created for a frothier cocktail (also good for an espresso martini or drinks containing eggs and dairy).

STIRRED

Fill a mixing glass one-half to two-thirds of the way with ice. Add the ingredients and stir briskly with a barspoon for 30 to 45 seconds. Pour through a strainer into the cocktail glass.

SHAKEN

Fill a cocktail shaker with ice, add ingredients, and replace shaker lid. Shake vigorously for 10 to 20 seconds, or until the outside of the shaker starts getting frosty. Pour through a strainer into the cocktail glass.

ICE

Ice is used to chill and dilute drinks but also to transform the presentation of the drink itself. Unless specified, if a drink uses ice in the cocktail glass, use fresh ice and discard the ice used in the mixing glass or cocktail shaker.

One large ice cube is recommended for stirred cocktails served on the rocks. The larger surface area melts more slowly to keep the drink cold without getting watered down as fast. If you don't have a larger mold, you can instead use several regular ice cubes.

Shaken drinks can be served over crushed ice, over cubes, or straight up (without ice).

Now you're ready to start making fabulous drinks inspired by Barbie, her many friends, and her adventures!

AMP UP YOUR ICE GAME

- Get creative with different shapes of ice cube molds like spheres, flowers, crystals, and more.
- Before filling the ice tray with water, add fruit or herbs to freeze into the cubes.
- Instead of water, freeze tea, juice, or coffee into cubes to use as the ice in the cocktail glass.

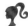

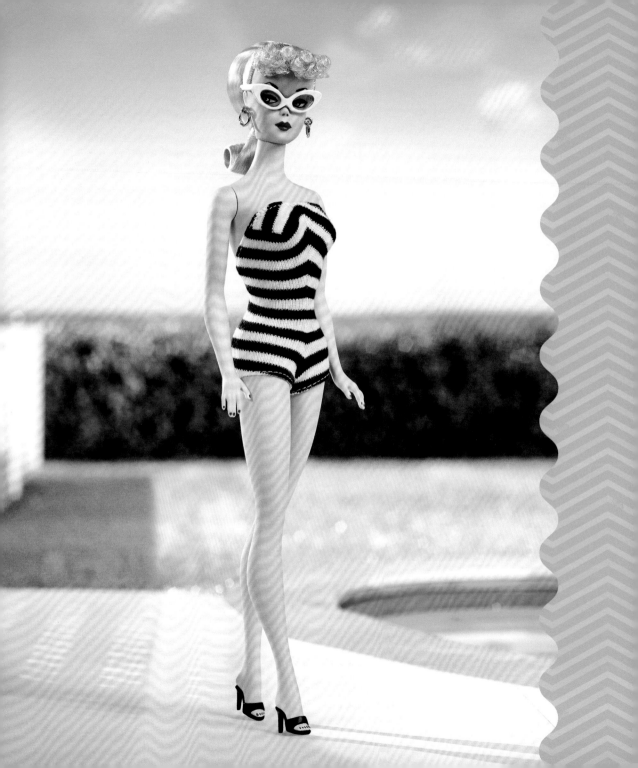

BARBIE FASHION THROUGH THE DECADES

Barbie has been a fashion icon from day one! Fashion can be a form of self-expression and creativity, and Barbie is an embodiment of both. Over the years she has donned outfits from high-fashion designers like Oscar de la Renta, Donna Karan, Hubert de Givenchy, and many more, and her wardrobe has often inspired human-sized looks to match. From the runway to the red carpet, these drinks are inspired by the many looks that have become synonymous with Barbie and her friends.

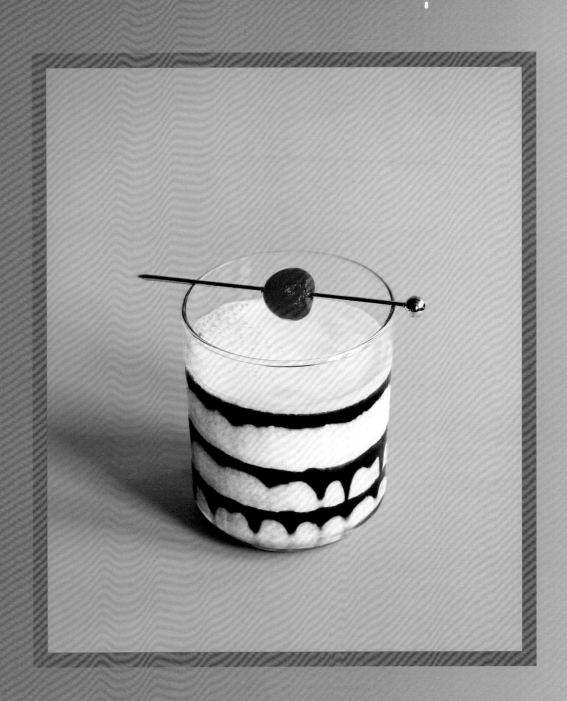

THE DEBUT

Barbie first launched at the American International Toy Fair in 1959 as a glamorous "Teen Age Fashion Model." For her first of over 250 careers, Barbie was dressed in her black-and-white striped swimsuit with a bold red lip, a departure from the baby dolls of the time. This mocktail pays tribute to one of her most iconic looks.

EQUIPMENT

ROCKS GLASS

SHAKER

STRAINER

RECIPE

CHOCOLATE SYRUP

4 OZ MILK

1 OZ HEAVY CREAM

½ OZ SIMPLE SYRUP

¼ TEASPOON VANILLA EXTRACT

PINCH OF SALT

OPTIONAL GARNISH: MARASCHINO CHERRY

Using a chocolate syrup bottle, draw circles of chocolate syrup on the inside of a rocks glass. Shake milk, cream, simple syrup, vanilla extract, and salt with ice until chilled. Strain into the rocks glass and garnish with a maraschino cherry.

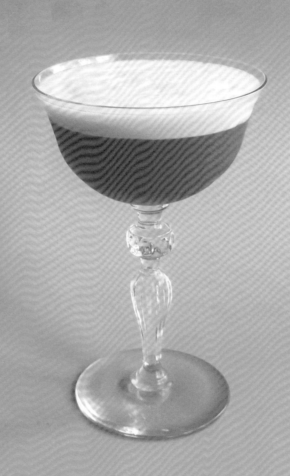

ENCHANTED EVENING

Wearing a stunning pink satin gown and a white fur stole, Barbie was fit for an elegant night on the town in this 1960 look. This mocktail mimics the classic outfit using egg white or aquafaba (chickpea liquid from the can) to create the fluffy foam atop the delicate pink base.

EQUIPMENT

SHAKER

STRAINER

COUPE GLASS

RECIPE

2 OZ COCONUT WATER

¾ OZ LIME JUICE

¼ OZ GRENADINE

¼ OZ SIMPLE SYRUP

1 OZ EGG WHITE OR AQUAFABA

Combine coconut water, lime juice, grenadine, simple syrup, and egg white or aquafaba in a shaker with ice and shake until chilled. Strain into a coupe.

COLOR MAGIC MARGARITA

Color Magic Barbie launched in 1966 with flare: her hair and swimsuit changed color! Mix up that same flare with this color-changing margarita featuring butterfly pea flower tea. Butterfly pea flowers boast natural colors known as anthocyanins, presenting as a stunning deep blue in water. These colors are sensitive to acid, so when the tea meets the tartness of the margarita, witness the transformation into a beautiful fuchsia shade.

EQUIPMENT

ROCKS GLASS

SHAKER

STRAINER

RECIPE

2 OZ TEQUILA

½ OZ TRIPLE SEC

1 OZ LIME JUICE

¾ OZ SIMPLE SYRUP

1 OZ BUTTERFLY PEA FLOWER TEA (PAGE 7), COOLED

OPTIONAL GARNISH: SALT, SUGAR

Rim a rocks glass with salt and/or sugar and fill with ice. Shake tequila, triple sec, lime juice, and simple syrup with ice and strain into the rocks glass. Pour cooled butterfly pea flower tea on top and watch the color change!

MAKE IT A MOCKTAIL

Instead of shaking up the tequila, triple sec, lime juice, and simple syrup, pour lemonade or limeade over ice. When you pour the cooled tea on top, the acid from the lemon or lime juice will still cause the beautiful color change.

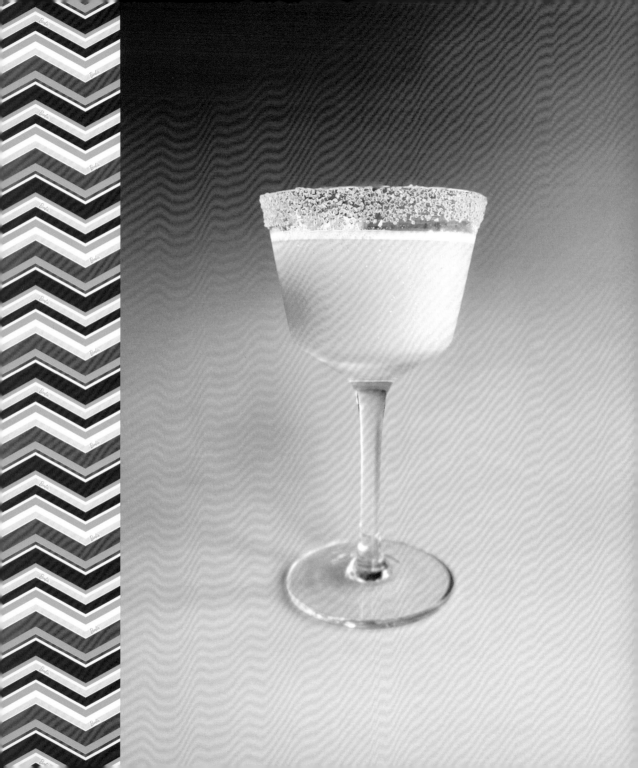

GOLDEN DREAM

Christie O'Neil debuted in 1968, and this shimmering cocktail pays homage to Golden Dream Christie: it captures the essence of her iconic 1981 ensemble featuring a dazzling jumpsuit adorned with sparkling gloves and a cape.

EQUIPMENT

COUPE GLASS

SHAKER

STRAINER

RECIPE

2 OZ PINEAPPLE JUICE

¾ OZ LIME JUICE

½ OZ PASSION FRUIT SYRUP

OPTIONAL: EDIBLE GLITTER

OPTIONAL GARNISH: GOLD SUGAR

Rim a coupe with gold sugar. Combine pineapple juice, lime juice, passion fruit syrup, and optional edible glitter to a shaker with ice and shake until chilled, and then strain into the coupe.

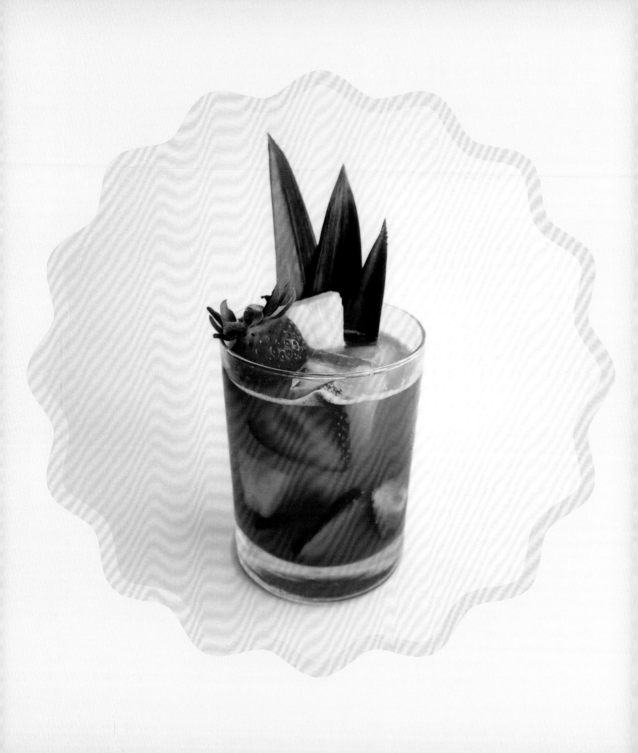

WHISKEY SMASHEROO

Barbie rocked the mod look for the winter in 1968 with her Smasheroo outfit, featuring red go-go boots, yellow fur hat and coat, yellow tights, and red dress. This whiskey smash has its own mod look with bright colors and bright flavors of strawberry and pineapple.

EQUIPMENT

ROCKS GLASS

SHAKER

MUDDLER

STRAINER

RECIPE

8 MINT LEAVES

2 STRAWBERRIES AND 3 PINEAPPLE CHUNKS
(FOR MUDDLING)

2 OZ WHISKEY

¾ OZ LEMON JUICE

¾ OZ SIMPLE SYRUP

OPTIONAL GARNISH: PINEAPPLE FRONDS,
PINEAPPLE AND STRAWBERRY SLICES

Fill a rocks glass with ice and a few slices of pineapple and strawberry. In a shaker, muddle mint, strawberries, and pineapple chunks. Add whiskey, lemon juice, and simple syrup. Shake 20 seconds and strain into the rocks glass. Garnish with pineapple fronds and pineapple and strawberry slices.

MAKE IT A MOCKTAIL

Swap the whiskey for a cooled black tea.

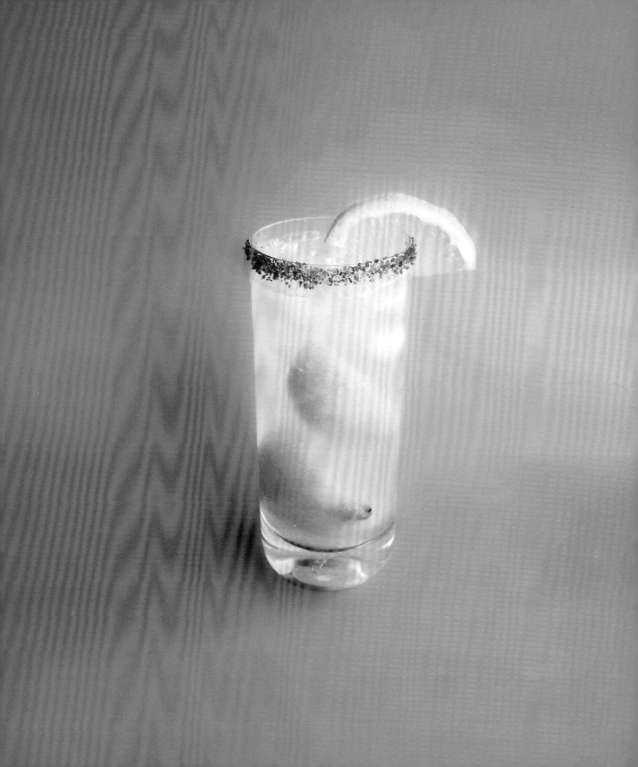

LEMON KICK-UP

Barbie kicked off 1970 with her Lemon Kick mod look: a head-to-toe yellow pleated ensemble with an empire waist and hot-pink bow. It's a hot look, so cool down with this Lemon Kick-Up. Like Barbie, it's a classic taken to new heights—this shaken version of a lemonade uses the whole lemon, peel and all!

EQUIPMENT

2 COLLINS GLASSES

SHAKER

MUDDLER

RECIPE (SERVES 2)

¼ CUP SUGAR

1 WHOLE LEMON

12 OZ WATER

OPTIONAL GARNISH: PINK SUGAR, LEMON SLICES

If desired, rim the Collins glasses with pink sugar. Add sugar to a cocktail shaker. Wash the lemon, and then cut it into quarters and add it to the shaker (yes, including the peel!). Muddle the lemon and sugar together and add ice and water. Shake for 1 minute and divide between two Collins glasses—no straining necessary, leave in the lemon! Add additional ice if desired, and garnish each glass with a lemon slice.

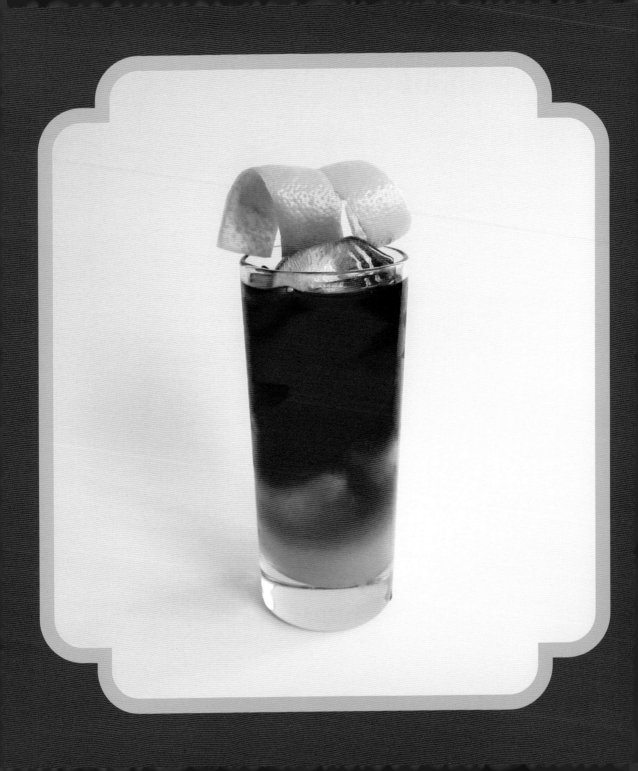

DAY-TO-NIGHT REFRESHER

Day-to-Night Barbie celebrated the working woman in 1985. By day she showcased a pink power suit alongside her hat and briefcase, and by night her outfit transformed into a sparkly pink evening gown perfect for a night on the town. These two drinks both feature pink hibiscus tea—first in a refreshing mocktail appropriate for the workday, and then infused into gin for a vivid and glittery martini for the post nine-to-five crowd.

EQUIPMENT

SHAKER

STRAINER

COLLINS GLASS

RECIPE

1 OZ GRAPEFRUIT JUICE

½ OZ LEMON JUICE

½ OZ SIMPLE SYRUP

3 OZ HIBISCUS TEA (PAGE 7), COOLED

OPTIONAL GARNISH: LEMON TWIST

Shake grapefruit juice, lemon juice, and simple syrup with ice. Strain into a Collins glass filled with ice. Top with cooled hibiscus tea and a lemon twist.

DAY-TO-NIGHT MARTINI

EQUIPMENT

BARSPOON

MIXING GLASS

COUPE GLASS

RECIPE

2 ½ OZ HIBISCUS-INFUSED GIN (PAGE 6)

½ OZ DRY VERMOUTH

OPTIONAL: EDIBLE GLITTER

Stir hibiscus gin, dry vermouth, and optional edible glitter with ice in a mixing glass for 30 to 60 seconds and strain into a coupe.

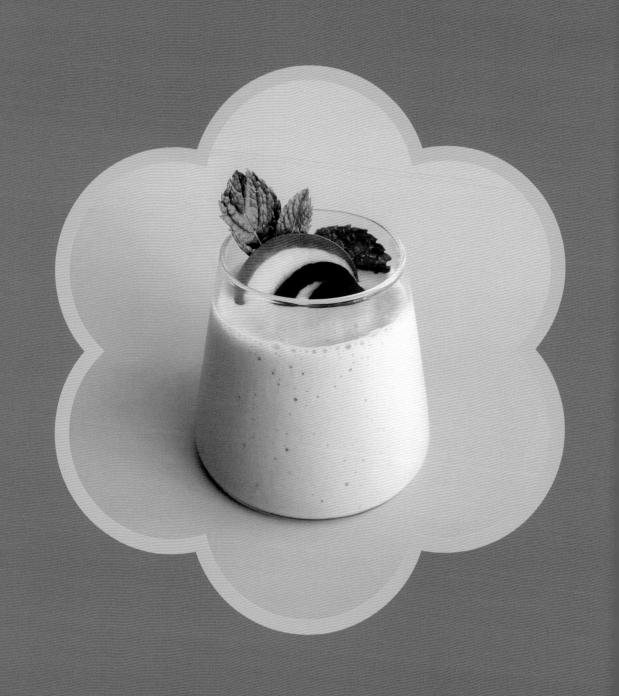

PEACHY KEEN

The year 1985 marked the entry of Peaches 'n Cream Barbie with a beautiful peach-colored chiffon gown. A look that is both delicate and over the top at the same time deserves a refreshment to match. This creamy creation uses frozen peaches instead of ice for a filling, nutritious smoothie that doesn't get watered down as it melts.

EQUIPMENT

BLENDER

ROCKS GLASS

RECIPE

1 CUP FROZEN PEACH PIECES

1/2 BANANA

1/3 CUP ALMOND MILK

1/4 CUP GREEK YOGURT

1 OZ HONEY SYRUP (PAGE 9)

OPTIONAL GARNISH: PEACH SLICE, MINT SPRIG

Add frozen peach pieces, banana, almond milk, Greek yogurt, and honey syrup to a blender and blend until smooth. Pour into a rocks glass and garnish with a slice of peach and a sprig of mint.

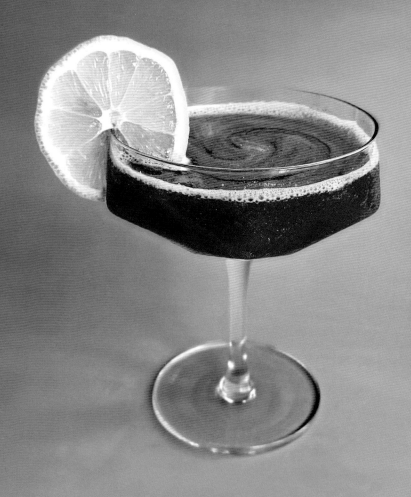

JAM 'N GLAM

The twenty-first century ushered in the Jam 'n Glam look. In 2001 Barbie and her friends Christie and Teresa all rocked this look as glamorous pop stars, hitting the stage with color-changing hair! Put on some tunes and glam up this cocktail with edible glitter and the berry jam of your choosing.

EQUIPMENT

SHAKER

STRAINER

COUPE GLASS

RECIPE

2 OZ VODKA

1 OZ LEMON JUICE

¾ OZ SIMPLE SYRUP

2 TEASPOONS BLACKBERRY, STRAWBERRY, OR RASPBERRY JAM

OPTIONAL: EDIBLE GLITTER

OPTIONAL GARNISH: LEMON SLICE

Shake vodka, lemon juice, simple syrup, jam of your choosing, and optional edible glitter until chilled and strain into a coupe. Garnish with a slice of lemon.

MAKE IT A MOCKTAIL

Prepare the drink without the vodka, and top with seltzer after straining into the coupe.

MAKING MEMORIES IN MALIBU

Barbie heads west to Malibu! Though she originally hails from Willows, Wisconsin, in 1971 the California surfer girl and her pals made their debut with eyes set on sunny days, sandy toes, and good times. Whether she's Rollerblading through Venice Beach or simply catching some waves, the Malibu lifestyle is embodied by soaking up the sun! Don't forget the sunscreen as you relax with these beachy beverages inspired by Barbie and her friends along the Malibu coast.

MALIBU SUNRISE

No matter where you are, take a sip of the beach life with the Malibu Sunrise: a smooth blend of coconut rum with tangy orange and pineapple juice. A touch of grenadine mimics a perfect beachside sunrise—ideal for beach days or poolside lounging, or just a little getaway in a glass!

EQUIPMENT

COLLINS GLASS

SHAKER

STRAINER

RECIPE

1 OZ WHITE RUM

½ OZ COCONUT RUM

1 ½ OZ ORANGE JUICE

1 ½ OZ PINEAPPLE JUICE

½ OZ GRENADINE

OPTIONAL GARNISH: ORANGE SLICE, PINEAPPLE WEDGE

Fill a Collins glass with ice. Shake rum, coconut rum, orange juice, and pineapple juice with ice and strain into the Collins glass and add grenadine. Garnish with an orange slice and a pineapple wedge.

MAKE IT A MOCKTAIL

Replace the rums with additional orange and pineapple juice or simply remove the rums and top with seltzer.

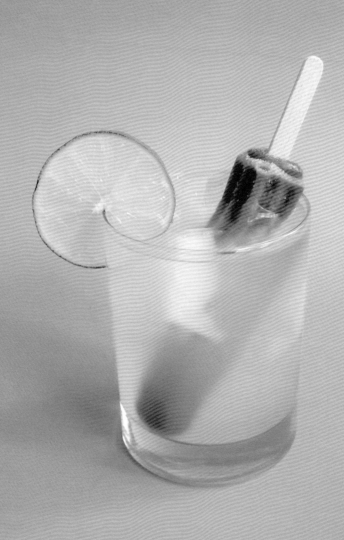

HEAT WAVE SUNSATION

Today's forecast: a heat wave incoming with this spicy limeade! Hotter than the beachy Sunsation looks, beat the heat with an ice pop to cool down—eat it separately or use it to infuse the limeade with an extra burst of flavor and chill.

EQUIPMENT

SHAKER

STRAINER

ROCKS GLASS(ES)

BARSPOON (BATCH VERSION ONLY)

PITCHER (BATCH VERSION ONLY)

RECIPE

1 OZ LIME JUICE

1 ½ OZ JALAPEÑO SIMPLE SYRUP (PAGE 10)

2 OZ COLD WATER

FRUIT JUICE ICE POP—TRY WATERMELON, ORANGE, OR STRAWBERRY!

OPTIONAL GARNISH: LIME WHEEL

For the single serving, shake the lime juice, jalapeño simple syrup, and water with ice before straining over fresh ice in a rocks glass. For the batch recipe, stir together lime juice, jalapeño simple syrup, and cold water in a pitcher. Top off with (or simply serve alongside) ice pop. Garnish with a wheel of lime.

BATCH RECIPE (SERVES 6 TO 8)

- 6 OZ LIME JUICE
- 9 OZ JALAPEÑO SIMPLE SYRUP (PAGE 10)
- 12 OZ COLD WATER
- 6 ICE POPS OF YOUR CHOOSING

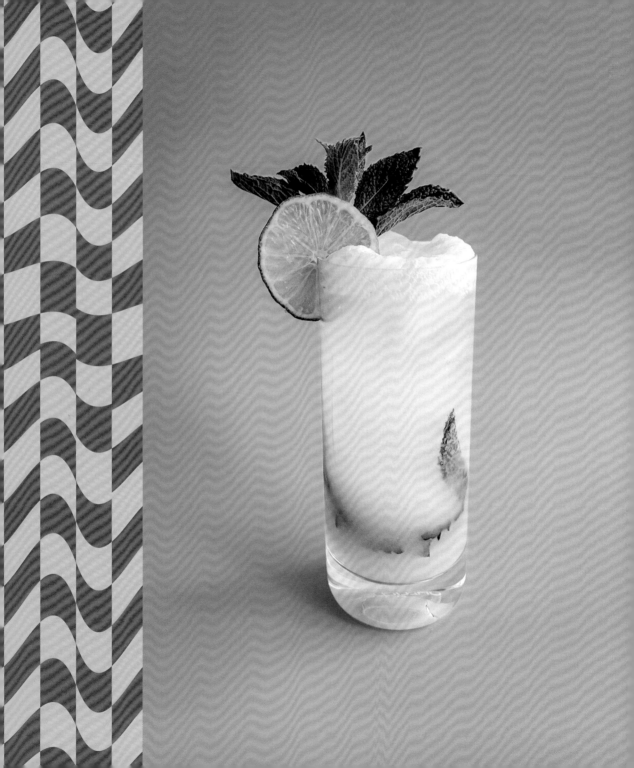

BEACHY MOJITO

Set up your beach umbrella, sit back in your lounge chair, and watch the waves with this coconut mojito in hand. Cheers to relaxing days on the beach with a drink that captures the essence of paradise.

EQUIPMENT

MUDDLER

COLLINS GLASS

SHAKER

STRAINER

RECIPE

3 TO 5 MINT LEAVES

1 ½ OZ WHITE RUM

½ OZ COCONUT RUM

¾ OZ LIME JUICE

½ OZ CREAM OF COCONUT

SELTZER TO TOP

OPTIONAL GARNISH: MINT SPRIG, LIME WHEEL

Muddle mint leaves in the bottom of a Collins glass. Shake rum, coconut rum, lime juice, and cream of coconut with ice until chilled, and strain into the Collins glass. Top with seltzer, and garnish with a sprig of mint and a wheel of lime.

MAKE IT A MOCKTAIL

Replace the white rum and coconut rum with coconut water.

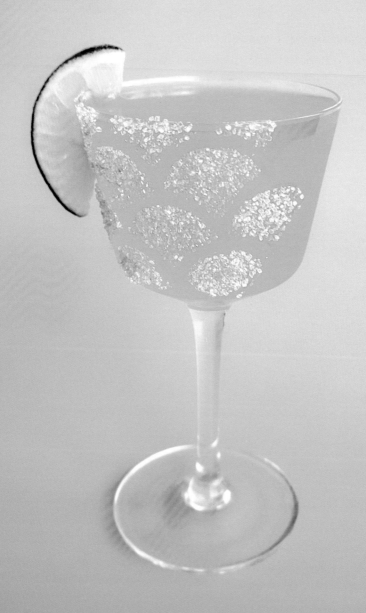

OCEAN BLUE DAIQUIRI

Just like the perfect matching colors can pull an outfit together, this Ocean Blue Daiquiri matches the drink in your hand to the waves at your feet. Add a playful touch to the presentation with colored sugar on the rim, or use a stencil to create a whimsical fish scale design!

EQUIPMENT

STENCIL

COUPE GLASS

SHAKER

STRAINER

RECIPE

2 OZ WHITE RUM

½ OZ BLUE CURAÇAO

¾ OZ LIME JUICE

½ OZ SIMPLE SYRUP

OPTIONAL GARNISH: COLORED SUGAR, LIME SLICE

Using a fish scale (or other design) stencil held against the coupe, apply a thin layer of simple syrup. With the stencil still in place, dip the coupe in colored sugar. Remove the stencil to reveal your design! Shake rum, blue curaçao, lime juice, and simple syrup with ice until chilled and strain into the prepared glass. Garnish with a slice of lime.

MAKE IT LOW ABV

Replace the rum with coconut water.

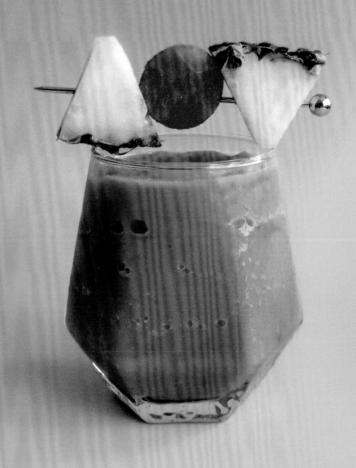

RENEE COUNTRY CAMPER COOLER

Renee Chao is a lover of the outdoors and a great friend to Barbie. Just as the Country Camper is the perfect place for the pals to gather after a long hike, this fruit-filled cooler will bring friends together to reflect on another great day and quality time together.

EQUIPMENT

BLENDER

ROCKS GLASS

RECIPE

1 CUP FROZEN WATERMELON CHUNKS (CUT INTO BITE-SIZE PIECES, BLACK SEEDS REMOVED)

8 OZ PINEAPPLE JUICE

1 OZ LIME JUICE

½ OZ SIMPLE SYRUP

OPTIONAL GARNISH: PINEAPPLE SLICES, WATERMELON PIECES

Blend frozen watermelon chunks, pineapple juice, lime juice, and simple syrup until smooth and pour into a rocks glass. Garnish with fresh pineapple and watermelon.

KEN COLLINS

Since 1961, Ken Carson has been accompanying Barbie on all sorts of adventures—from fun beach days Rollerblading in Malibu, to dazzling dream trips on shimmering ski slopes—they always have a great time together! Nowadays he's passionate about all things beach related—surfing, sailing, training to be a lifeguard, and maybe even becoming a marine biologist. Ken is reliable and refreshing, just like this riff on the Tom Collins.

EQUIPMENT

SHAKER

STRAINER

COLLINS GLASS

RECIPE

1 ½ OZ AMERICAN GIN

½ OZ VODKA

¼ OZ TRIPLE SEC

½ OZ SIMPLE SYRUP

¾ OZ LEMON JUICE

SELTZER TO TOP

OPTIONAL GARNISH: LEMON TWIST

Shake gin, vodka, triple sec, simple syrup, and lemon juice with ice until chilled. Strain into a Collins glass over fresh ice, top with seltzer, and garnish with a lemon twist.

ALLAN COLLINS

Allan Sherwood joined the scene briefly in 1964 and then again in the '90s. He was a friend to Ken and Barbie, bringing his own unique persona to the group. Allan's drink is a nonalcoholic version of Ken's, a lovely light sparkling lemonade. Add some flair with colored sugar on the rim to match Allan's signature polo shirt.

EQUIPMENT

COLLINS GLASS

SPOON

RECIPE

1 OZ SIMPLE SYRUP

1 OZ LEMON JUICE

SELTZER

OPTIONAL GARNISH: COLORED SUGAR, LEMON SLICE

Rim a Collins glass with colored sugar. Pour simple syrup, lemon juice, and seltzer into the Collins glass over crushed ice and stir. Garnish with a slice of lemon.

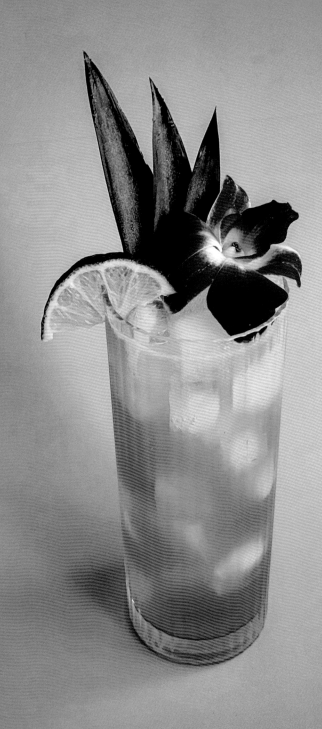

ISLAND QUEEN ICED TEA

An East Coast classic for West Coast royalty, the Island Queen Iced Tea is a Malibu-inspired version of a Long Island iced tea. Complete with a crown of pineapple fronds and a bounty of different spirits, this cocktail packs a punch!

EQUIPMENT

COLLINS GLASS OR PINT GLASS

SHAKER

STRAINER

RECIPE

¾ OZ COCONUT RUM

¾ OZ PISCO

¾ OZ GIN

¾ OZ TEQUILA

¾ OZ TRIPLE SEC

1 OZ LIME JUICE

½ OZ HIBISCUS SIMPLE SYRUP (PAGE 9)

SELTZER TO TOP

OPTIONAL GARNISH: LIME SLICE, EDIBLE FLOWER, PINEAPPLE FRONDS

Add ice to a Collins glass or pint glass. Shake coconut rum, pisco, gin, tequila, triple sec, lime juice, and hibiscus simple syrup with ice and strain into the Collins glass. Top with seltzer and garnish with a slice of lime, an edible flower, and pineapple fronds.

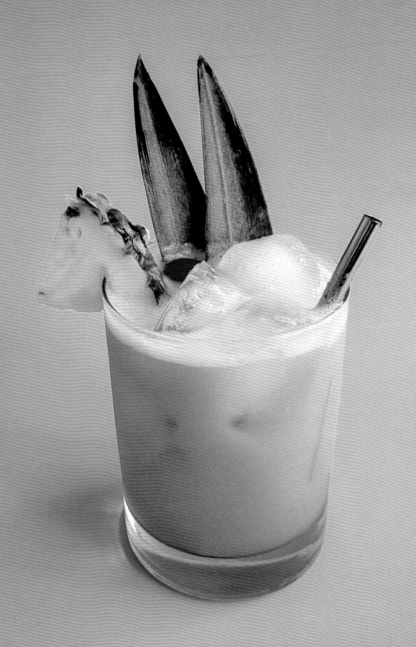

ROSA COLADA

The piña colada is the ultimate taste of the tropics—but is it pink enough? It is now! Your choice of hibiscus syrup or grenadine gives this shaken cocktail a rosy pink twist. The creamy coconut and tangy pineapple capture the essence of a sunny day at the beach, so sit back, unwind, and find your personal paradise.

EQUIPMENT

SHAKER

STRAINER

ROCKS GLASS

RECIPE

2 OZ WHITE RUM

1 ½ OZ PINEAPPLE JUICE

1 OZ CREAM OF COCONUT

½ OZ GRENADINE OR HIBISCUS SIMPLE SYRUP (PAGE 9)

½ OZ LIME JUICE

OPTIONAL GARNISH: MARASCHINO CHERRY, PINEAPPLE FRONDS, PINEAPPLE SLICE

Shake rum, pineapple juice, cream of coconut, grenadine or hibiscus simple syrup, and lime juice with ice until chilled. Strain over ice into a rocks glass and garnish with a maraschino cherry, pineapple fronds, and a slice of fresh pineapple.

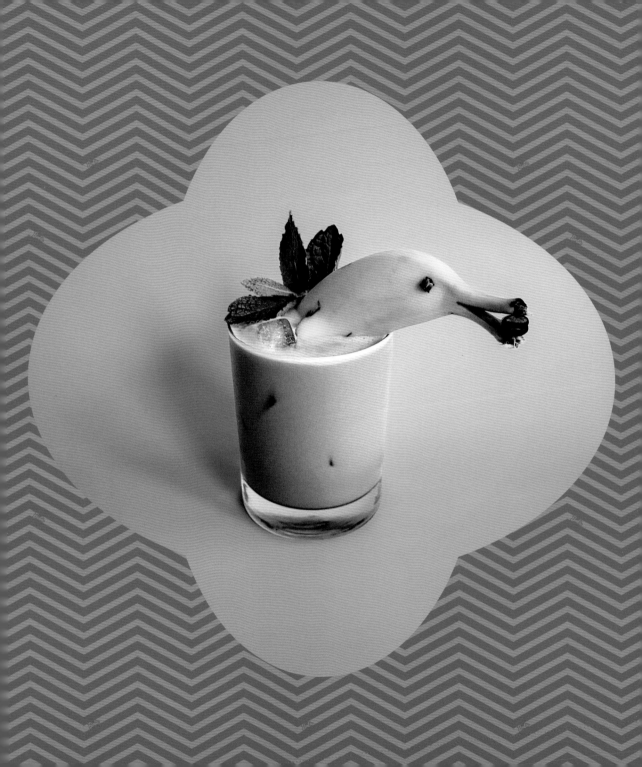

LEAPIN' DOLPHIN COFFEE

Indulge in a coffee cocktail with friends—including dolphin and sea creature friends! This tropically inspired coffee cocktail is served with an edible garnish that doubles as an adorable work of art. The dolphin garnish can be made with half a banana, inserting whole cloves into the peel as the eyes and carefully slicing the stem for a mouth and peel for the fins. For a final fun touch, add a coffee bean to the dolphin's mouth.

EQUIPMENT

SHAKER

STRAINER

ROCKS GLASS

RECIPE

2 OZ WHITE RUM

¾ OZ COFFEE LIQUEUR

¾ OZ BANANA LIQUEUR

1 ½ OZ COLD BREW COFFEE CONCENTRATE OR 1 SHOT ESPRESSO, COOLED

1 OZ COCONUT MILK

OPTIONAL: ¼ OZ CREAM OF COCONUT (IF YOU LIKE YOUR COFEE ON THE SWEETER SIDE)

OPTIONAL GARNISH: MINT SPRIG, BANANA DOLPHIN

Shake rum, coffee liqueur, banana liqueur, cold brew concentrate or cooled espresso, coconut milk, and optional cream of coconut with ice until chilled. Strain over ice in a rocks glass and garnish with a sprig of mint and a banana dolphin.

MAKE IT LOW ABV

Replace the rum with milk or extra coconut milk.

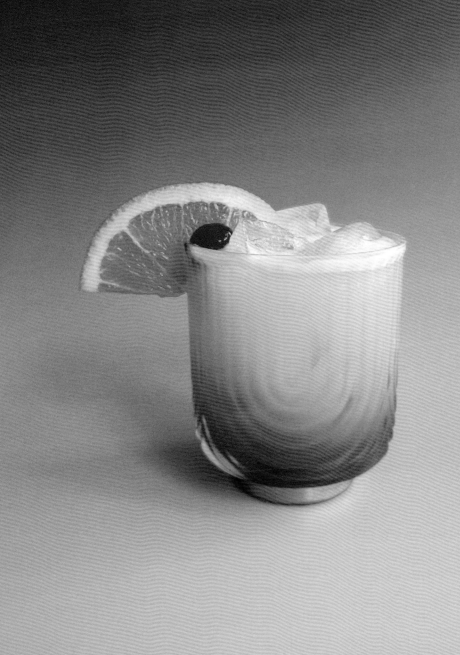

SUNSET BY THE SEA

There's nothing like watching the sunset over the ocean while a salty sea breeze fills the air. This tropical tipple mirrors the golden-to-ruby hues of the setting sun, with a pinch of salt to enhance the flavors.

EQUIPMENT

SHAKER

STRAINER

ROCKS GLASS

RECIPE

1 ½ OZ TEQUILA

½ OZ TRIPLE SEC

1 ½ OZ ORANGE JUICE

1 OZ MANGO JUICE

¼ OZ LIME JUICE

PINCH OF SALT

1 OZ CRANBERRY JUICE

OPTIONAL GARNISH: ORANGE SLICE, MARASCHINO CHERRY

Shake tequila, triple sec, orange juice, mango juice, lime juice, and salt with ice until chilled. Strain over fresh ice in a rocks glass, and then pour the cranberry juice on top. Garnish with a slice of orange and a maraschino cherry.

MAKE IT A MOCKTAIL

Replace the tequila and triple sec with a cooled black tea, or make the drink without the liquors and top with seltzer after pouring over ice.

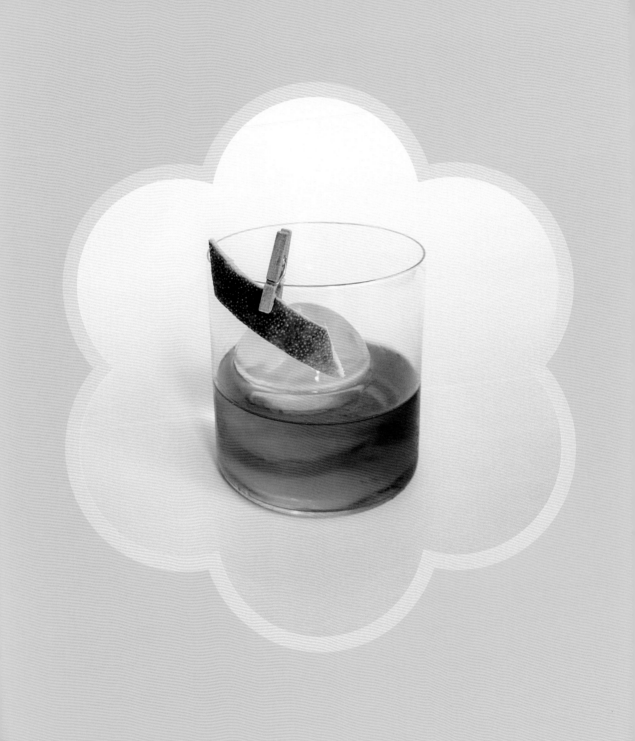

OASIS OLD-FASHIONED

Even in Malibu, with its exciting beach volleyball games and thrilling surfing, there's always time for you to slow down and savor the moment. This slow sipper is a beachy take on an old-fashioned, with golden and coconut rums that are tropical without being fruity or tart. Sip slowly as you picture yourself on sandy shores walking among the palm trees.

EQUIPMENT

BARSPOON

MIXING GLASS

STRAINER

ROCKS GLASS

Stir rum, coconut rum, simple syrup, and bitters with ice until chilled in a mixing glass. Strain over a large ice cube into a rocks glass and garnish with a lime peel.

RECIPE

2 OZ GOLD RUM

¼ OZ COCONUT RUM

¼ OZ SIMPLE SYRUP

2 TO 3 DASHES ANGOSTURA BITTERS

OPTIONAL GARNISH: LIME PEEL

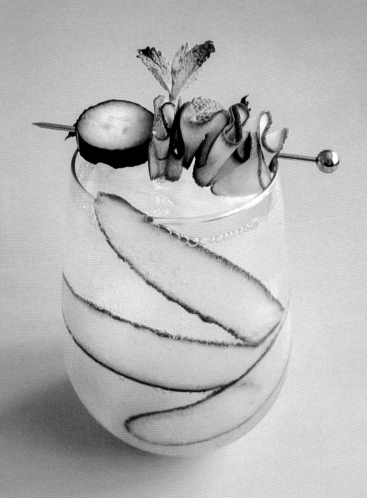

SPA DAY SPRITZ

There's nothing like a self-care day to refresh and reset. This spritz will help you do just that, whether you're spending time at home alone with a good book or having a day out at the spa with your friends. Put your feet up and relax with this iced chamomile and cucumber mocktail.

EQUIPMENT

VEGETABLE PEELER

ROCKS GLASS OR COUPE GLASS

SHAKER

MUDDLER

STRAINER

RECIPE

1 MEDIUM CUCUMBER

1 TO 2 SLICES OF FRESH GINGER (ABOUT THE SIZE OF A QUARTER, 1/3 INCH THICK)

3 TO 5 MINT LEAVES

3 OZ CHAMOMILE TEA, COOLED

½ OZ LEMON JUICE

½ OZ SIMPLE SYRUP

SELTZER TO TOP

OPTIONAL GARNISH: CUCUMBER, MINT

Using a vegetable peeler, peel 3 to 4 ribbons of cucumber from end to end and place them inside a rocks glass or stemless coupe, and then fill with ice. Cut the cucumber into three ½-inch-thick slices and place the slices in a cocktail shaker, along with the ginger and mint leaves. Muddle the cucumber, ginger, and mint, and then add chamomile tea, lemon juice, simple syrup, and ice. Shake until chilled, strain into the prepared glass, and top with seltzer. To garnish, skewer a cucumber ribbon on a cocktail pick, followed by a slice of cucumber. Place the skewered garnish on the drink, and stick a sprig of mint into the ice.

BARBIECORE

If there's anything that Barbie is well known for, it's her signature pink! Barbie embraced this vibrant hue in 1977 with the debut of Superstar Barbie, who wore a stunning pink gown and fabulous pink ruffled boa. Since then, Barbie has become forever linked with pink. She looks great in every shade, whether it's her very own Power Pink, dusty rose, hot pink, magenta, bubblegum, pastel pink, or fuchsia! There is power and beauty and strength in the many shades of pink, and these beverages pay tribute.

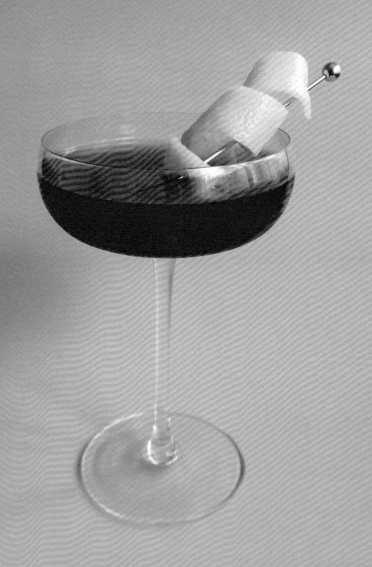

POWER PINK COSMO

The Pantone Color Matching System provides a universal language for colors, allowing people around the world to identify the exact shade of a color they wish to use. Barbie knows exactly what shade of pink to use, because Pantone 806, also known as Power Pink, is a bold, bright pink designed just for her!

EQUIPMENT

SHAKER

STRAINER

COUPE GLASS

RECIPE

1 ½ OZ HIBISCUS-INFUSED GIN (PAGE 6)

¾ OZ TRIPLE SEC

1 OZ CRANBERRY JUICE

¼ OZ LIME JUICE

OPTIONAL GARNISH: LEMON TWIST

Shake hibiscus gin, triple sec, cranberry juice, and lime juice with ice until chilled and strain into a coupe. Garnish with a twist of lemon.

MAKE IT LOW ABV

Swap out the hibiscus gin with cooled hibiscus tea.

SUGAR'S SALTY DOG

Ken's dapper Palm Beach 'fit is a green damask blazer, a pink button-up shirt, and white pants—but the look isn't complete without his small white dog, Sugar. The addition of salt in this cocktail helps to dial down some of the natural bitterness in grapefruit, with a bit of simple syrup to make it a little sweet—just like Sugar!

EQUIPMENT

ROCKS GLASS

SHAKER

STRAINER

RECIPE

3 OZ GRAPEFRUIT JUICE

1 ½ OZ VODKA

¼ OZ SIMPLE SYRUP

PINCH OF SALT

OPTIONAL GARNISH: SALT, SUGAR, GRAPEFRUIT TWIST

Rim a rocks glass with salt and sugar and fill with ice. Shake grapefruit juice, vodka, simple syrup, and a pinch of salt with ice and strain into the rocks glass. Garnish with a grapefruit twist.

MAKE IT A MOCKTAIL

Replace the vodka with a cooled tea like chamomile, or simply remove the vodka and top the drink with seltzer.

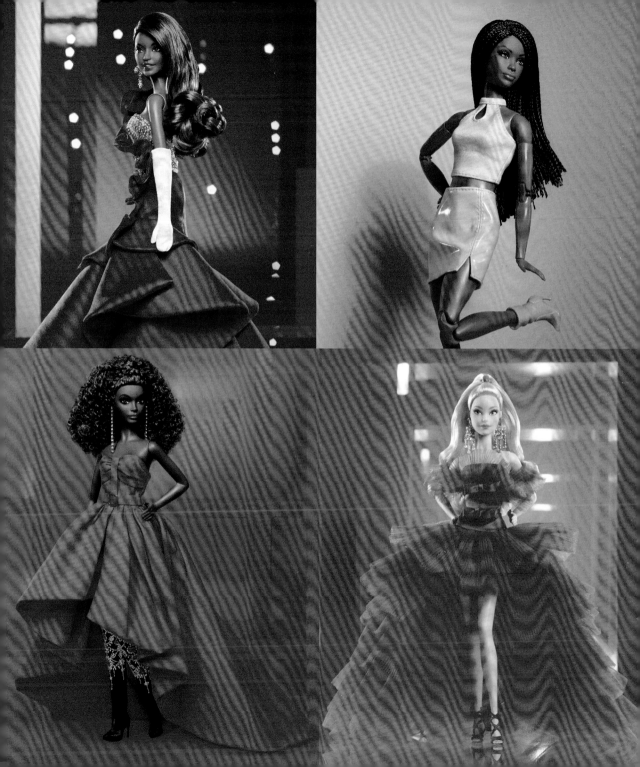

THINK PINK MARGARITA

This vibrant twist on the classic margarita brings a pop of color with hibiscus tea. The best part is, you choose your favorite way to think pink: add it to the shaker for a bold color throughout or pour the cooled tea on top after mixing the tequila, triple sec, lime, and simple syrup for a fun layered effect!

EQUIPMENT

ROCKS GLASS

SHAKER

STRAINER

RECIPE

2 OZ TEQUILA

½ OZ TRIPLE SEC

1 OZ LIME JUICE

¾ OZ SIMPLE SYRUP

½ OZ HIBISCUS TEA (PAGE 7), COOLED

OPTIONAL GARNISH: SALT, LIME WEDGE

Rim a rocks glass with salt and fill it with ice. Shake tequila, triple sec, lime juice, simple syrup, and hibiscus tea with ice and strain into the rocks glass. Garnish with a wedge of lime.

MAKE IT A MOCKTAIL

Replace the tequila and triple sec with a cooled tea.

HIBISCUS BEE'S KNEES

Beekeeper Barbie knows bees, and bees know flowers. Hibiscus flowers are large and impossibly pink—and they're edible! Make homemade hibiscus gin for a flower-infused update to the classic bee's knees cocktail. In addition to maintaining the ecosystem and pollinating crops, the bees have also provided the perfect sweetener for this drink.

EQUIPMENT

SHAKER

STRAINER

COUPE GLASS

RECIPE

2 OZ HIBISCUS-INFUSED GIN (PAGE 6)

1 OZ LEMON JUICE

¾ OZ HONEY SYRUP (PAGE 9)

OPTIONAL GARNISH: EDIBLE FLOWERS OR
LEMON SLICE

Shake hibiscus gin, lemon juice, and honey syrup with ice until chilled and strain into a chilled coupe. Garnish with edible flowers or a slice of lemon.

MAKE IT A MOCKTAIL

Switch out the hibiscus-infused gin for cooled hibiscus tea—for all of the color with none of the alcohol!

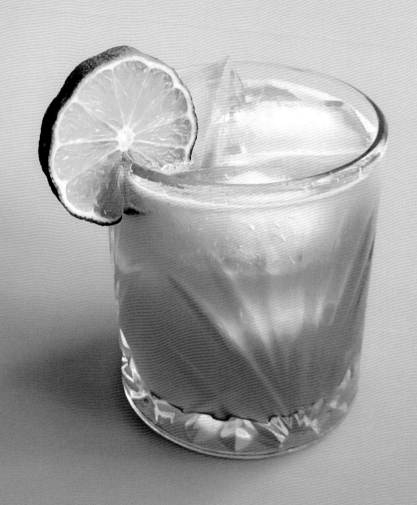

THE PINK DRINK

Grapefruit meets grenadine meets tequila in The Pink Drink: a sweet and tangy sipper served over ice. It's the perfect drink for a sunny afternoon or a night out with friends!

EQUIPMENT

ROCKS GLASS

SHAKER

STRAINER

RECIPE

2 OZ TEQUILA

½ OZ TRIPLE SEC

1 OZ GRAPEFRUIT JUICE

¾ OZ LIME JUICE

½ OZ SIMPLE SYRUP

1 TEASPOON GRENADINE

OPTIONAL GARNISH: LIME SLICE

Add ice to a rocks glass. Shake tequila, triple sec, grapefruit juice, lime juice, simple syrup, and grenadine with ice and strain into the rocks glass. Garnish with a slice of lime.

MAKE IT A MOCKTAIL

Remove the tequila and triple sec; shake the grapefruit juice, lime juice, simple syrup, and grenadine with ice and strain over fresh ice, and then top with seltzer.

SPARKLING PINK BELLINI

Amp up your brunch game with an extra fabulous bubbly beverage! A Bellini is usually made with prosecco and peach purée, but pink it up with this version using sparkling rosé, pink grapefruit juice, and edible glitter to make it truly sparkle.

EQUIPMENT

SHAKER

STRAINER

CHAMPAGNE FLUTE OR WINEGLASS

RECIPE

1 ½ OZ PINK GRAPEFRUIT JUICE

¾ OZ ELDERFLOWER LIQUEUR

3 TO 4 OZ SPARKLING ROSÉ

OPTIONAL: EDIBLE GLITTER

OPTIONAL GARNISH: GRAPEFRUIT PEEL

Shake grapefruit juice, elderflower liqueur, and optional edible glitter with ice and strain into a champagne flute or wineglass. Top with sparkling rosé and garnish with a grapefruit peel.

MAKE IT LOW ABV

Use sparkling grape juice in place of sparkling rosé.

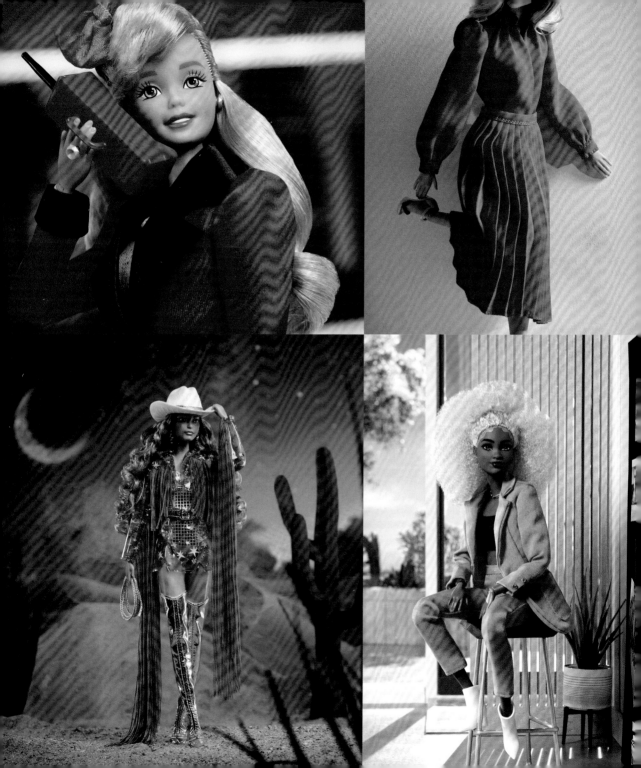

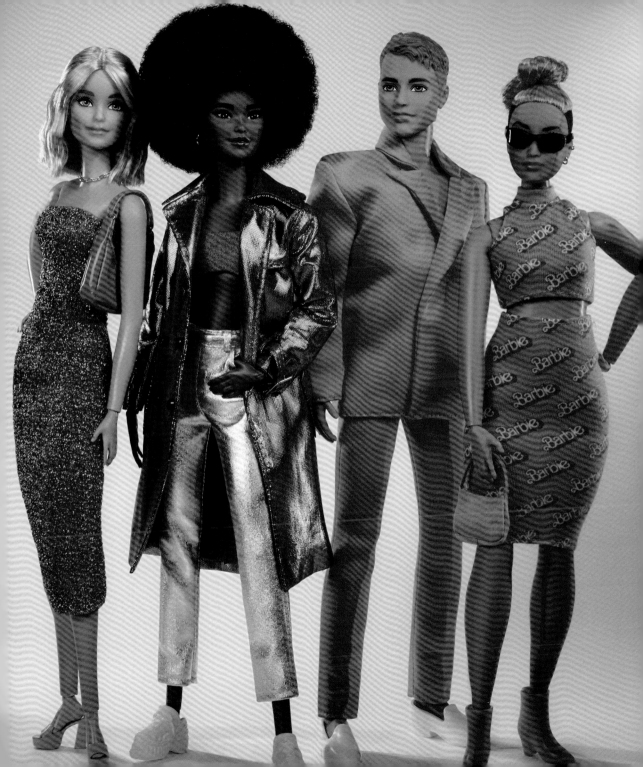

PINK, PINKER, AND PINKEST LEMONADE

Introducing three refreshing lemonades bursting with citrusy goodness: Pink Lemonade, Pinker Lemonade, and Pinkest Lemonade. Pink Lemonade, the classic favorite, combines the zest of lemons with delicious strawberries for a pale rosy hue that delights both the eyes and the taste buds. Stepping it up, Pinker Lemonade intensifies the pink with the addition of raspberries *and* strawberries, delivering a bolder berry flavor and color. And for those seeking the ultimate in pink perfection, Pinkest Lemonade reigns supreme, with an electrifying pink color and an explosion of berries. Whether you're cooling off on a sunny day or simply craving summer in a glass, these lemonades will quench your thirst and brighten your day.

EQUIPMENT

MUDDLER

SHAKER

STRAINER

COLLINS GLASS

PINK LEMONADE

2 TO 3 STRAWBERRIES, SLICED

1 OZ SIMPLE SYRUP

1 OZ LEMON JUICE

2 OZ WATER

OPTIONAL GARNISH: STRAWBERRY

Muddle strawberry slices in a shaker and then add ice, simple syrup, lemon juice, and water. Shake with ice until chilled and strain over fresh ice in a Collins glass. Garnish with a strawberry.

PINKER LEMONADE

2 TO 3 STRAWBERRIES, SLICED

3 RASPBERRIES

1 OZ SIMPLE SYRUP

1 OZ LEMON JUICE

2 OZ WATER

OPTIONAL GARNISH: RASPBERRY, STRAWBERRY SLICE

Muddle strawberry slices and raspberries in a shaker and then add ice, simple syrup, lemon juice, and water. Shake with ice until chilled and strain over fresh ice in a Collins glass. Garnish with a raspberry and a slice of strawberry.

PINKEST LEMONADE

2 TO 3 STRAWBERRIES, SLICED

3 RASPBERRIES

1 OZ HIBISCUS SIMPLE SYRUP (PAGE 9)

1 OZ LEMON JUICE

2 OZ WATER

OPTIONAL GARNISH: EDIBLE FLOWER

Muddle strawberry slices and raspberries in a shaker and then add ice, hibiscus simple syrup, lemon juice, and water. Shake with ice until chilled and strain over fresh ice in a Collins glass. Garnish with an edible flower.

JET SET SIPPERS

From Malibu to Brooklyn to across the ocean, Barbie has traveled far and wide on all sorts of adventures. She has even had several careers focused on travel, including tour guide, pilot, and photojournalist! Whether it's for work or for leisure, traveling can be a great way to break out of your regular routine or even your comfort zone. Set forth on your own adventure and sip your way around the globe with these travel-inspired mocktails and cocktails.

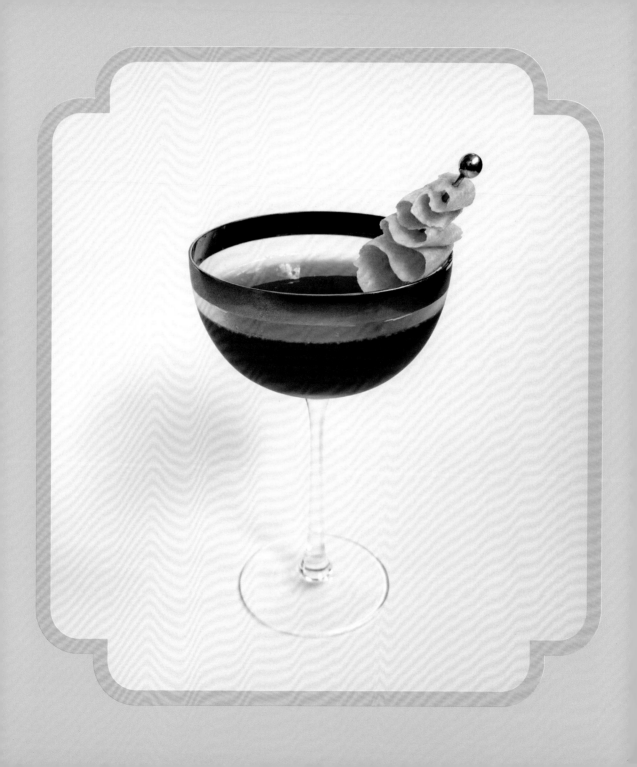

READY, SET, VACAY!

Barbie has traversed the globe to embark on all kinds of adventures, from hitting the snowy ski slopes to exploring bustling city streets. The sky is the limit with this delightful twist on the classic aviation cocktail, typically made with gin, maraschino liqueur, and lemon juice. For a vibrant hue, opt for a homemade or store-bought butterfly pea flower–infused gin. No passport required—just shake, sip, and get away!

EQUIPMENT

SHAKER

STRAINER

COUPE GLASS

RECIPE

2 OZ BUTTERFLY PEA FLOWER–INFUSED GIN (PAGE 6)

½ OZ MARASCHINO LIQUEUR

¾ OZ LEMON JUICE

¼ OZ GRENADINE

OPTIONAL GARNISH: LEMON TWIST

Shake butterfly pea flower gin, maraschino liqueur, lemon juice, and grenadine with ice until chilled, and strain into a chilled coupe. Garnish with a twist of lemon.

MAKE IT LOW ABV

Replace the butterfly pea flower–infused gin with butterfly pea flower tea.

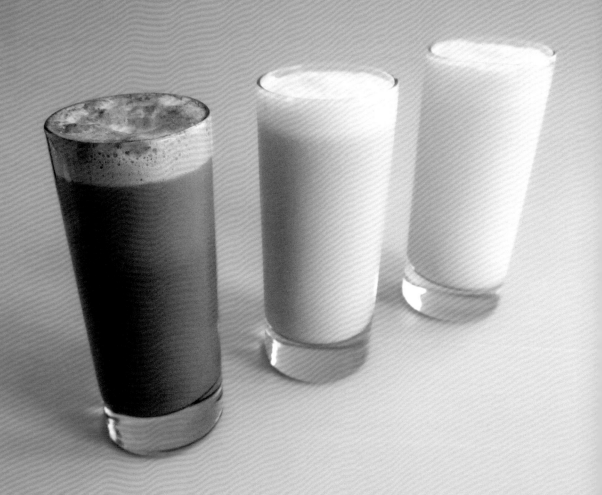

SODA SHOPPE EGG CREAM

Did you know that Barbie is a nickname? Her full name is Barbara Millicent Roberts—and there are two of her! Barbie "Malibu" Roberts from California and Barbie "Brooklyn" Roberts from New York City are best friends, sometimes calling each other Brooklyn and Malibu. Despite the name, this New York soda fountain classic contains neither eggs nor cream, but it's a classic nonetheless! The traditional flavor for an egg cream is chocolate, but there are limitless possibilities using different flavors of syrup like vanilla and hazelnut or flavored seltzer.

EQUIPMENT

COLLINS GLASS

BARSPOON

RECIPE

1 ½ OZ CHOCOLATE SYRUP OR 1 OZ OF OTHER-FLAVORED SYRUP

3 OZ MILK

5 OZ SELTZER

Add syrup to a Collins glass, followed by milk. Top with seltzer and stir to combine. If you prefer a sweeter, fizzier, or creamier drink, you can adjust from there—it's easy to customize since all the mixing happens in the drinking glass!

FOR SYRUP FLAVORS, stick with syrups that would go well added to coffee or hot chocolate (acidic syrups can curdle the milk). You can add a fruity touch by using flavored seltzer instead of plain.

SUGGESTED COMBINATIONS

- Chocolate syrup with raspberry-flavored seltzer
- Hazelnut syrup with orange-flavored seltzer
- Toasted marshmallow syrup (page 10) with vanilla-flavored seltzer

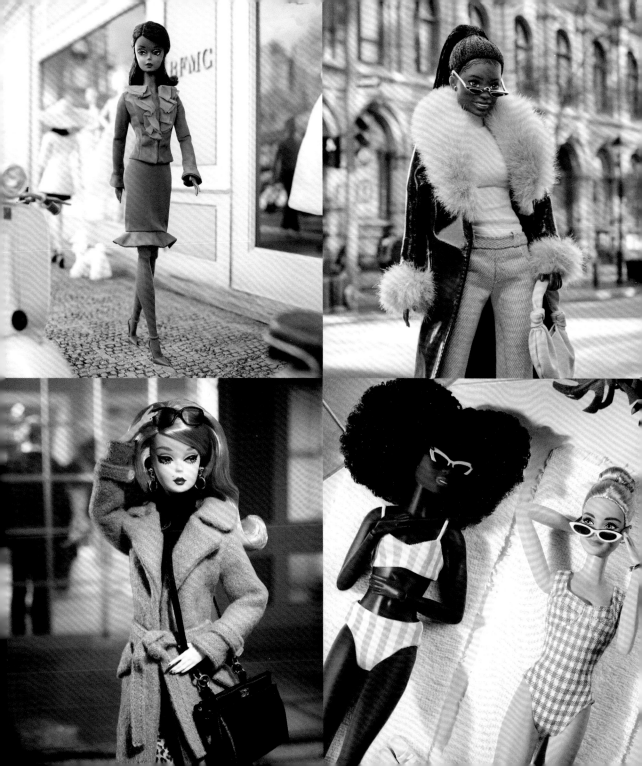

RED-EYE ESPRESSO MARTINI

When jetting off for a trip, sometimes there's no other option than to take a late-night flight. Enter the Red-Eye Espresso Martini! Whether you want a caffeinated concoction to energize your travels or prefer to use decaf espresso for a restful slumber on your flight, the Red-Eye Espresso Martini is the perfect travel companion.

EQUIPMENT

SHAKER

STRAINER

COUPE GLASS

RECIPE

1 ½ OZ COLD BREW COFFEE CONCENTRATE OR 1 SHOT ESPRESSO, COOLED

1 ½ OZ VODKA

1 OZ COFFEE LIQUEUR

¾ OZ HEAVY CREAM

OPTIONAL: ¼ OZ SIMPLE SYRUP

OPTIONAL GARNISH: COFFEE BEANS

Shake cold brew concentrate or cooled espresso, vodka, coffee liqueur, heavy cream, and optional simple syrup with ice until chilled. Strain into a coupe and garnish with coffee beans.

MAKE IT LOW ABV

Swap out the vodka for milk or half and half for an extra creamy drink.

PINK PISCO SOUR

Jet over to South America for the pisco sour, the national drink of Peru. Pisco, a spirit that originates in Peru, is made from distilling fermented grape juice. The classic pisco sour typically draws its pale green color from lime juice, but this version is playfully pink with the subtle floral flavor of hibiscus.

EQUIPMENT

SHAKER

STRAINER

COUPE GLASS

RECIPE

2 OZ PISCO

¾ OZ LIME JUICE

½ OZ HIBISCUS SIMPLE SYRUP (PAGE 9)

1 OZ EGG WHITE OR AQUAFABA

OPTIONAL GARNISH: LIME SLICE, ANGOSTURA BITTERS

Shake pisco, lime juice, hibiscus simple syrup, and egg white or aquafaba with ice until chilled and strain into a chilled coupe. Garnish with a slice of lime and a few drops of bitters in the foam. Use a toothpick to swirl the bitters.

APRÈS-SKI HOT TODDY

Barbie first competed in the Winter Olympics in the '70s, hitting the slopes and going for the win. Après-ski is a tradition meant to chase away the chill after a thrilling day of skiing, and this hot toddy does just that. Picture yourself nestled in a cozy chalet as you reminisce about (or plan ahead for) a ski adventure on the mountainside.

EQUIPMENT

MUG

SPOON

RECIPE

1 ½ OZ WHISKEY

¼ OZ LEMON JUICE

½ OZ HONEY SYRUP (PAGE 9)

4 TO 6 OZ HOT WATER

OPTIONAL GARNISH: LEMON SLICE
WITH CLOVES

Add whiskey, lemon juice, and honey syrup to a mug. Top with hot water, stir to combine, and garnish with a lemon slice studded with cloves.

MAKE IT A MOCKTAIL

Remove the whiskey and increase the hot water or use hot tea instead.

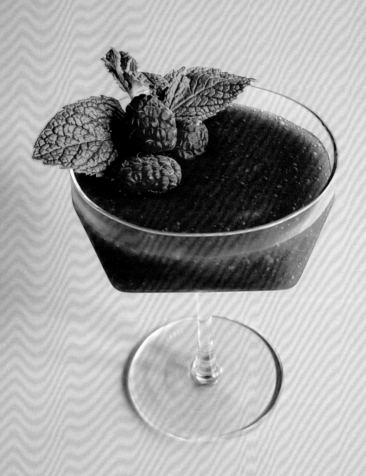

RASPBERRY SGROPPINO

This concoction takes you right to Italy—a tantalizing blend of sorbet, sparkling wine, and vodka. The Sgroppino is traditionally served during dinner to cleanse the palate between courses. The original recipe features lemon sorbet, but this version introduces the luscious flavors of raspberry. And of course, you're invited to experiment with the fruit sorbet of your choosing to personalize the drink!

EQUIPMENT

BLENDER OR MIXING GLASS AND IMMERSION BLENDER

COUPE GLASS(ES)

In a blender or mixing glass using an immersion blender, blend sparkling wine, vodka, and raspberry sorbet until smooth. Pour into a chilled coupe and garnish with raspberries and a sprig of mint.

RECIPE

2 OZ SPARKLING WINE

1 OZ VODKA

1 SCOOP (ABOUT ¼ CUP) RASPBERRY SORBET

OPTIONAL GARNISH: RASPBERRIES, MINT SPRIG

BATCH RECIPE (SERVES 6)

- **375 ML BOTTLE SPARKLING WINE**
- **6 OZ VODKA**
- **1 ½ CUPS RASPBERRY SORBET**
- **OPTIONAL GARNISH: RASPBERRIES, MINT SPRIG**

Add sparkling wine, vodka, and sorbet to a blender and blend until smooth. Pour into chilled coupes immediately and garnish with raspberries and a sprig of mint.

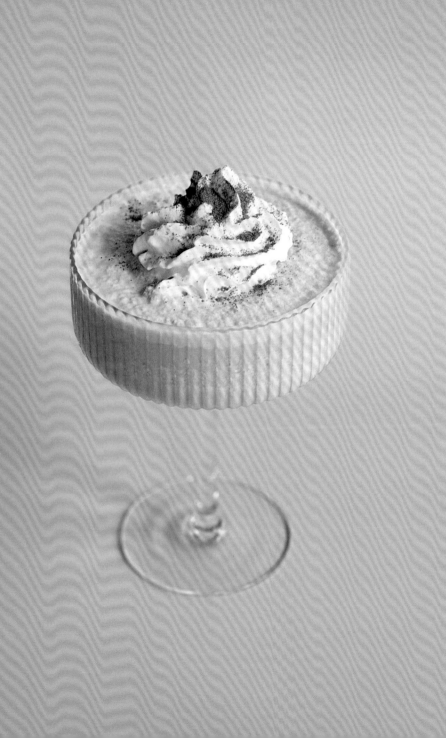

COOKIE BUTTER FRAPPÉ

Embrace your inner barista with a blended coffee drink, featuring *speculoos* spread. Speculoos is a spiced cookie originating in Belgium and is now often seen in a spreadable "cookie butter" form. It's a key ingredient in this frozen treat that will have you dreaming of wandering the streets of Bruges. If you can't find speculoos, try substituting it with Nutella for a chocolatey twist!

EQUIPMENT

BLENDER OR MIXING GLASS AND IMMERSION BLENDER

COUPE GLASS

RECIPE

1 ½ OZ COLD BREW CONCENTRATE OR 1 SHOT ESPRESSO, COOLED

1 OZ MILK

1 OZ HEAVY CREAM

¾ OZ BROWN SUGAR SIMPLE SYRUP (PAGE 8)

1 TABLESPOON SPECULOOS (COOKIE BUTTER)

1 CUP ICE

OPTIONAL GARNISH: WHIPPED CREAM, CINNAMON

Add cold brew concentrate or cooled espresso, milk, cream, brown sugar simple syrup, speculoos, and ice to a blender or mixing glass if using an immersion blender. Blend until smooth and pour into a chilled coupe. Top with whipped cream and cinnamon.

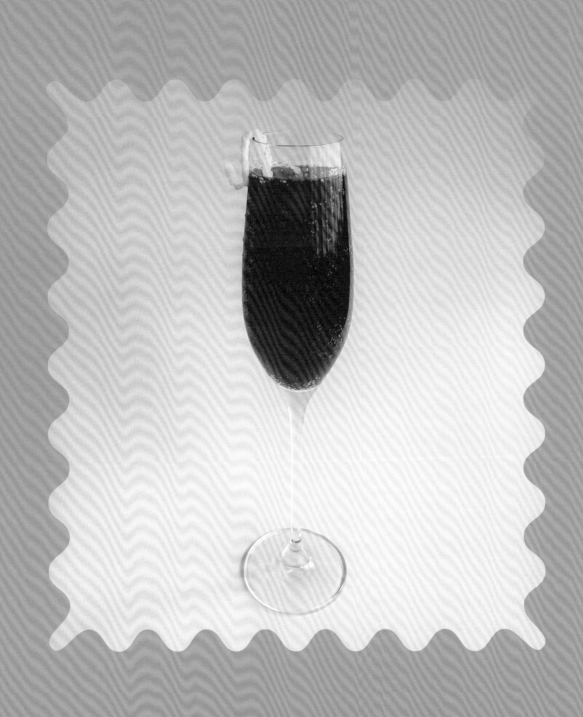

FRENCH 59

The French 75 is classic, strong, and elegant—what better way to toast Barbie at her dazzling 1959 debut at the American International Toy Fair? This was the start of her journey to become a global icon, and this French 59 can be the start of a great night out with friends!

EQUIPMENT

SHAKER

STRAINER

CHAMPAGNE FLUTE(S) OR WINEGLASS(ES)

PITCHER (BATCH VERSION ONLY)

Shake hibiscus gin, lemon juice, and simple syrup with ice until chilled. Strain into a champagne flute or wineglass, top with sparkling wine, and garnish with a lemon twist.

RECIPE

1 OZ HIBISCUS-INFUSED GIN (PAGE 6)

½ OZ LEMON JUICE

½ OZ SIMPLE SYRUP

3 OZ SPARKLING WINE

OPTIONAL GARNISH: LEMON TWIST

BATCH RECIPE (SERVES 8 TO 12)

- **8 OZ HIBISCUS-INFUSED GIN (PAGE 6)**
- **4 OZ LEMON JUICE**
- **4 OZ SIMPLE SYRUP**
- **750 ML BOTTLE SPARKLING WINE**
- **OPTIONAL GARNISH: LEMON TWISTS**

Shake hibiscus gin, lemon juice, and simple syrup with ice until chilled, and strain into a pitcher until ready to serve. Add mix to your guests' glasses, top with sparkling wine, and garnish with a lemon twist.

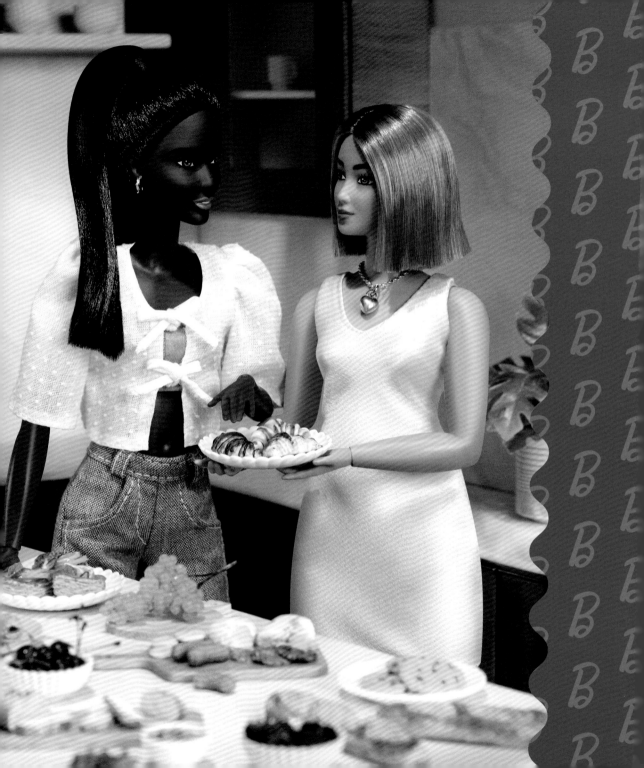

BARBIE DREAM WORLD

Barbie has had all sorts of adventures around the world, but there's no place like the DreamHouse. What better place to host her friends? Indulge in these drinks inspired by her iconic DreamHouse as Barbie entertains friends and shares a bit of DreamHouse living. In fact any movie night, any pool party, any space where you can enjoy your own company or spend time with the people you care about can be your very own DreamHouse!

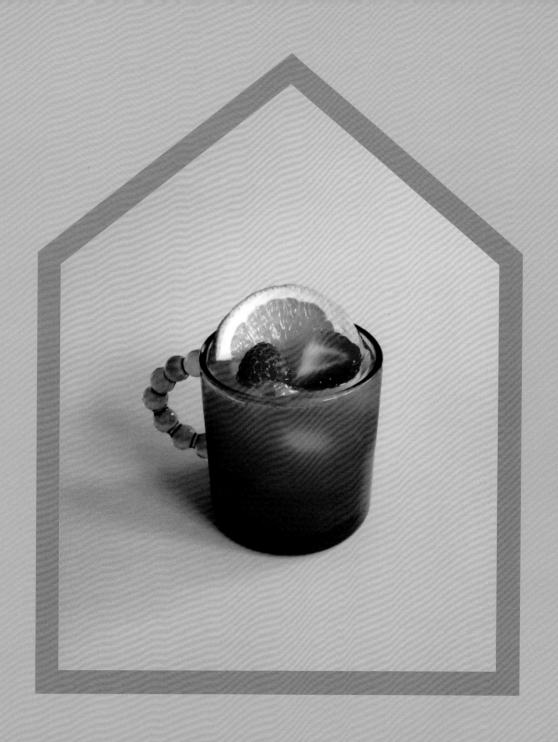

DREAMHOUSE-WARMING PUNCH

Barbie owned her very first DreamHouse in 1962 at a time when women rarely owned their own homes. The DreamHouse has gone through many beloved iterations, ranging from a classic A-frame to an adorable cottage, to a mansion three stories high with features like slides, pools, and even elevators for accessibility. Celebrate her DreamHouse with a festive punch just for you, or mix up a batch big enough for a group!

EQUIPMENT

ROCKS GLASS(ES) OR MUG(S)

BARSPOON (BATCH VERSION ONLY)

PUNCH BOWL OR LARGE PITCHER (BATCH VERSION ONLY)

Pour pineapple juice, orange juice, grenadine, lime juice, and seltzer over ice in a rocks glass or mug. Garnish with sliced orange, strawberries, and raspberries.

RECIPE

2 OZ PINEAPPLE JUICE

1 OZ ORANGE JUICE

½ OZ GRENADINE

½ OZ LIME JUICE

2 OZ SELTZER

OPTIONAL GARNISH: SLICED ORANGE, STRAWBERRIES, RASPBERRIES

BATCH RECIPE (SERVES 10)

- 20 OZ PINEAPPLE JUICE
- 10 OZ ORANGE JUICE
- 5 OZ GRENADINE
- 5 OZ LIME JUICE
- 20 OZ SELTZER
- 1 ORANGE, SLICED AND FROZEN
- 1 CUP EACH STRAWBERRIES AND RASPBERRIES, FROZEN

Stir together pineapple juice, orange juice, grenadine, lime juice, and seltzer in a punch bowl or large pitcher. Add your frozen fruit to keep the punch cold without getting watered down. To serve, ladle or pour into rocks glasses or mugs filled with ice.

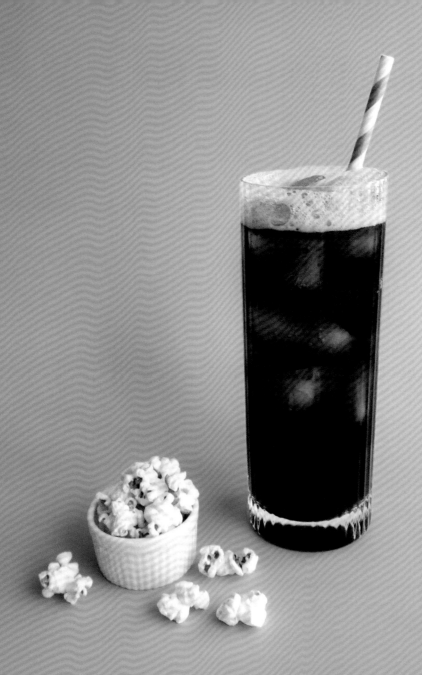

MOVIE NIGHT

Settle in for a movie night at home with a drink (and snack) fit for the big screen! The Barbie Movie Star doll hit the red carpet in 1999 in a shimmering purple gown, but there's nothing like staying in and enjoying a classic flick with a few friends on movie night. The fizz of Coke with a splash of rum, lime, and coffee liqueur creates the perfect accompaniment to your cinematic adventures. So sit back and enjoy the show—and don't forget the popcorn!

EQUIPMENT

COLLINS GLASS

RECIPE

1 ½ OZ GOLD RUM

¾ OZ COFFEE LIQUEUR

½ OZ LIME JUICE

7 OZ COKE

OPTIONAL GARNISH: POPCORN

Add ice to a Collins glass. Pour rum, coffee liqueur, lime juice, and Coke on top. Garnish with popcorn.

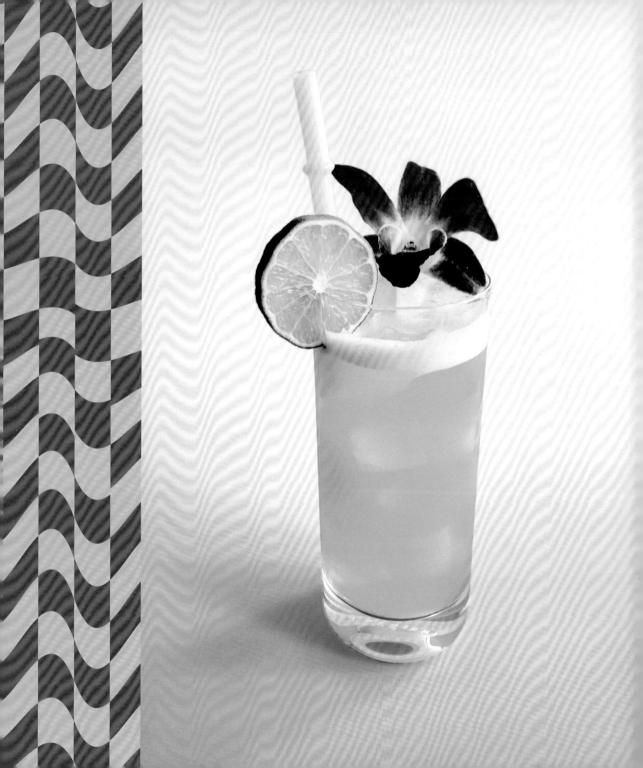

POOLSIDE PUNCH

What's a DreamHouse without a slide into your very own pool? Whether you're hosting a poolside party or simply lounging in the sun, make a splash with this refreshing punch.

EQUIPMENT

SHAKER

STRAINER

COLLINS GLASS(ES)

BARSPOON (BATCH VERSION ONLY)

PUNCH BOWL OR PITCHER (BATCH VERSION ONLY)

RECIPE

2 OZ WHITE RUM

½ OZ BLUE CURAÇAO

1 ½ OZ COCONUT WATER

1 OZ PINEAPPLE JUICE

¼ OZ LIME JUICE

1 TEASPOON SIMPLE SYRUP

OPTIONAL GARNISH: LIME WHEEL, EDIBLE FLOWER

Shake rum, blue curaçao, coconut water, pineapple juice, lime juice, and simple syrup with ice and strain into a Collins glass over fresh ice. Garnish with a wheel of lime or edible flower.

MAKE IT LOW ABV

Replace white rum with additional coconut water, or remove white rum and top with seltzer after shaking.

BATCH RECIPE (SERVES 4 TO 6)

- **8 OZ WHITE RUM**
- **2 OZ BLUE CURAÇAO**
- **6 OZ COCONUT WATER**
- **4 OZ PINEAPPLE JUICE**
- **1 OZ LIME JUICE**
- **1 TABLESPOON PLUS 1 TEASPOON SIMPLE SYRUP**

Stir rum, blue curaçao, coconut water, pineapple juice, lime juice, and simple syrup in a punch bowl or pitcher with ice and serve immediately.

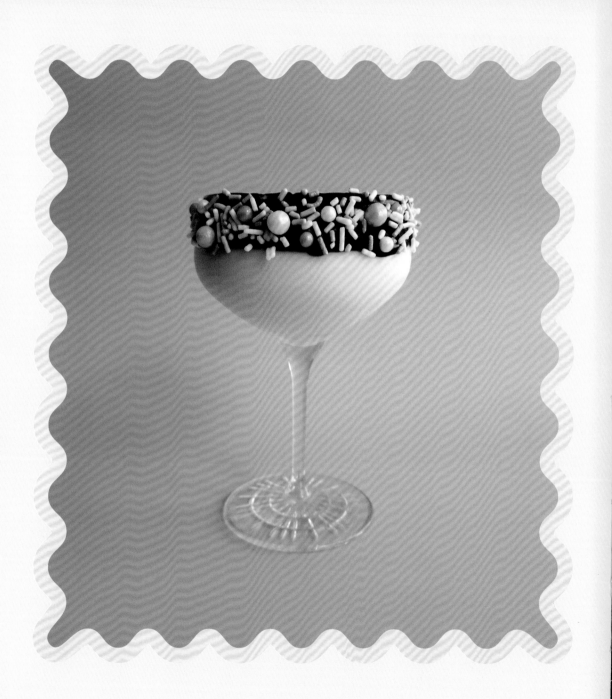

CUPCAKE FLIP

Try this totally sweet treat of a drink that Pastry Chef Barbie would totally ace—and you can too. This cake-infused flip contains a whole egg, which adds a luxurious custard texture and flavor. Decorate the rim of the glass with frosting and sprinkles for a sip that's beyond decadent!

EQUIPMENT

SMALL JAR

COUPE GLASS

SHAKER

STRAINER

RECIPE

2 OZ YELLOW CAKE MILK

½ OZ HEAVY CREAM

¾ OZ BROWN SUGAR SIMPLE SYRUP (PAGE 8)

¼ TEASPOON VANILLA EXTRACT

1 EGG

PINCH OF SALT

OPTIONAL GARNISH: FROSTING, SPRINKLES

FOR YELLOW CAKE MILK: Take a 2 x 2–inch piece of yellow cake and tear it into a few pieces and place it in a small jar. Add 8 oz of milk, shake the jar, and refrigerate for 1 to 2 hours. Shake again and then strain the cake out of the milk. Any leftover cake milk can be kept in the fridge for 2 to 3 days—if you don't drink it all right away!

Dip a coupe in frosting and decorate with sprinkles as desired. Shake yellow cake milk, cream, brown sugar simple syrup, vanilla extract, egg, and salt with ice until chilled and strain into the prepared coupe.

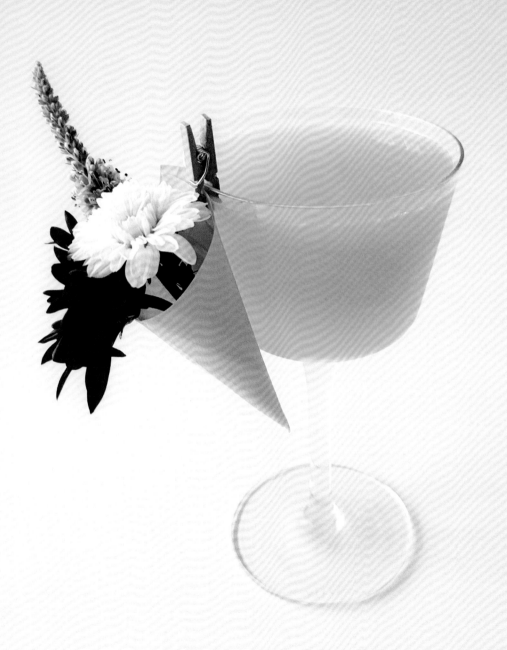

FLOWER GARDEN GIMLET

In a vase or growing in the garden outside, flowers can be a beautiful (and sometimes edible!) decoration. Shake up a refreshingly floral sip with elderflower liqueur alongside a syrup infused with edible rose petals or vibrant hibiscus.

EQUIPMENT

SHAKER

STRAINER

COUPE GLASS

RECIPE

2 OZ VODKA

½ OZ ROSE PETAL SIMPLE SYRUP OR HIBISCUS SIMPLE SYRUP (PAGE 9)

½ OZ ELDERFLOWER LIQUEUR

¾ OZ LIME JUICE

OPTIONAL GARNISH: EDIBLE FLOWERS

Shake vodka, rose petal or hibiscus simple syrup, elderflower liqueur, and lime juice with ice until chilled. Strain into a chilled coupe and garnish with edible flowers.

MAKE IT LOW ABV

Instead of vodka, try using a cooled tea like chamomile, jasmine, or hibiscus.

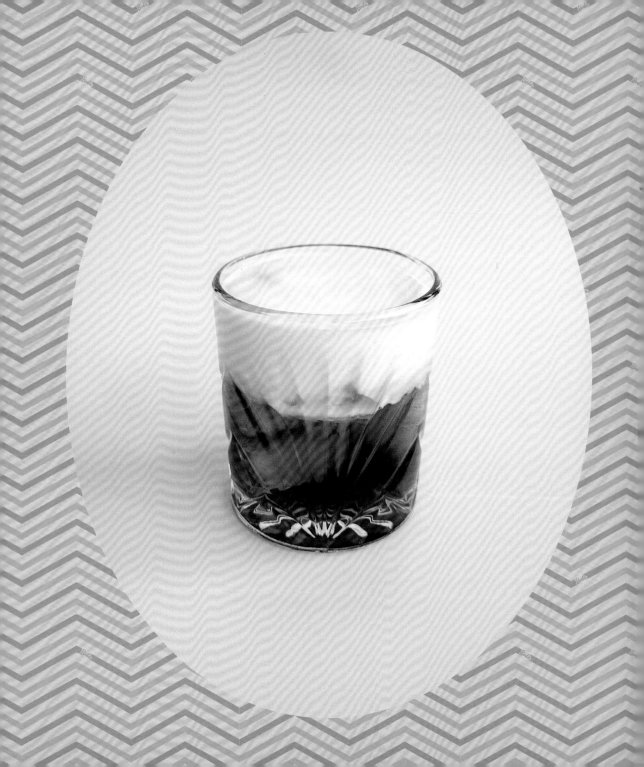

RUM AND JAVA REVIVAL

This cocktail gives a second life to spent coffee grounds (already used to brew coffee). Instead of throwing them away, use them to make a coffee-infused rum!

EQUIPMENT

SMALL JAR

COFFEE FILTER

BARSPOON

MIXING GLASS

STRAINER

ROCKS GLASS

FROTHER

RECIPE

2 OZ COFFEE-INFUSED RUM

½ OZ BROWN SUGAR SIMPLE SYRUP (PAGE 8)

1 OZ MILK OR HALF AND HALF

PINCH OF CINNAMON

FOR COFFEE-INFUSED RUM: Add 6 tablespoons of used coffee grounds to a small jar with 2 oz of white rum. Let infuse for 3 to 4 hours, and strain through a coffee filter. (You might get slightly less than 2 oz after straining—this is fine!)

In a mixing glass, stir the coffee-infused rum with brown sugar simple syrup over ice until chilled, and strain over a large cube of ice into a rocks glass. Froth milk or half and half with a pinch of cinnamon until approximately doubled in size and pour on top.

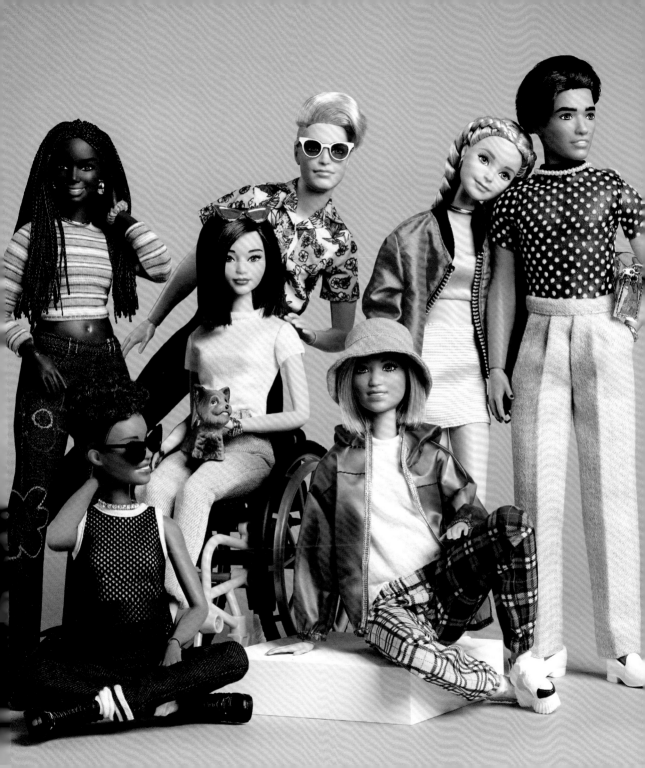

VEGGIE PATCH SPRITZ

Do you have a green thumb? Whether the vegetables grew in your very own Dream-House vegetable patch or you picked them up from a farmers' market, you can drink your veggies with a refreshing savory mocktail.

EQUIPMENT

VEGETABLE PEELER

COLLINS GLASS

SHAKER

STRAINER

RECIPE

1 MEDIUM CUCUMBER

2 OZ CARROT JUICE

½ OZ LIME JUICE

½ OZ PICKLE BRINE

¼ OZ SIMPLE SYRUP

SELTZER TO TOP

OPTIONAL GARNISH: CUCUMBER RIBBON, MINT SPRIG

Using a vegetable peeler, peel 3 to 4 ribbons of cucumber from end to end and place them inside a Collins glass, and then fill with ice. Shake carrot juice, lime juice, pickle brine, and simple syrup with ice and strain into the Collins glass, and then top with seltzer. To garnish, roll an additional cucumber ribbon, stick a cocktail pick through the middle, and then add a sprig of mint to the top.

TOASTED MARSHMALLOW OLD-FASHIONED

Start up the campfire, toast some marshmallows, and make s'mores—or enjoy this Toasted Marshmallow Old-Fashioned! This cocktail promises to elevate your outdoor experience with its cozy flavors and nostalgic charm, whether you're gathering with friends around the backyard firepit at the DreamHouse or venturing out with Barbie in the Dream Camper.

EQUIPMENT

ROCKS GLASS

BARSPOON

MIXING GLASS

STRAINER

RECIPE

2 OZ WHISKEY

¼ OZ CRÈME DE CACAO

¼ OZ TOASTED MARSHMALLOW SYRUP (PAGE 10)

OPTIONAL GARNISH: MELTED CHOCOLATE OR CHOCOLATE SYRUP, GRAHAM CRACKERS

Dip a rocks glass into melted chocolate or chocolate syrup, and sprinkle with graham cracker crumbs if desired. Stir together whiskey, crème de cacao, and toasted marshmallow syrup with ice in a mixing glass until chilled. Strain into the rocks glass over a large cube or sphere of ice.

TEA PARTY

Teresa Rivera was introduced as a good friend to Barbie in 1988—she loves science and is passionate about her hobbies and friends. In 1995, My First Tea Party Teresa launched—why not enjoy the company of friends and family with a tea party of your own? Brew this chamomile, fruit, and mint tea in a teapot or French press. Serve hot or allow to cool and pour over ice.

EQUIPMENT

TEAPOT OR FRENCH PRESS

TEACUPS

OPTIONAL: STRAINER

RECIPE (SERVES 4 TO 6)

HALF AN ORANGE, SLICED

HALF A LEMON, SLICED

½ CUP PINEAPPLE CHUNKS

2 TO 3 MINT SPRIGS

3 CHAMOMILE TEA BAGS (OR 3 TEASPOONS LOOSE-LEAF CHAMOMILE TEA)

½ OZ HONEY

BOILING WATER

OPTIONAL GARNISH: LEMON AND ORANGE SLICES

Add the orange, lemon, pineapple, mint, tea, and honey to a 4 to 6 cup teapot or French press and top with boiling water. Brew for 5 to 6 minutes, and pour (straining if necessary) into teacups. Serve with additional honey for your guests to add as needed. Garnish with slices of lemon and orange.

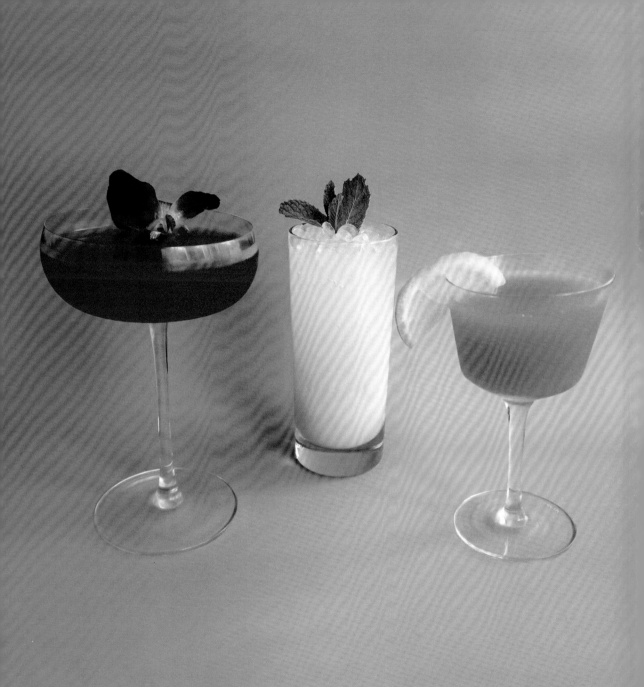

DREAM CLOSET

With all the fashions and careers Barbie has rocked over the years, her closet and possible outfit combinations are seemingly endless. The same can be true of cocktails and mocktails! There are so many ingredient options that can be mixed and matched that a truly customized drink can be created with limitless possibilities. Use the suggestions below as a starting point to create your own drink.

CHOOSE YOUR GLASSWARE

COUPE (SERVED STRAIGHT UP, WITHOUT ICE)

COLLINS (OVER ICE, TOPPED WITH SELTZER)

CHOOSE YOUR BASE

2 OZ COOLED TEA, COCONUT WATER, VODKA, GIN, TEQUILA, OR RUM

CHOOSE YOUR CITRUS

¾ OZ LEMON OR LIME JUICE (OR USE A MIX OF THE TWO)

CHOOSE YOUR SYRUP

¾ OZ SIMPLE SYRUP, HONEY SYRUP, HIBISCUS SYRUP, GRENADINE, PASSION FRUIT SYRUP, OR ANY OTHER SYRUP

OPTIONAL: MUDDLE MINT OR FRUIT IN YOUR SHAKER BEFORE ADDING THE BASE, CITRUS, AND SYRUP.

CHOOSE YOUR GARNISH

SLICES OF FRUIT

SPRIG OF MINT OR OTHER HERBS

EDIBLE FLOWERS

SUGAR OR SALT ON THE RIM (IF USING, PREPARE YOUR GLASS BEFORE MIXING THE DRINK!)

If using, muddle mint or fruit in your cocktail shaker, and then add your base, citrus, syrup, and ice. Shake until chilled and strain into a coupe or over fresh ice in a Collins glass. Top with seltzer if using a Collins glass. Add the garnish of your choice and enjoy your new creation!

ACKNOWLEDGMENTS

Thank you to my husband, Brandon, for helping talk through ideas, taste test cocktails, and generally find the words to make this book happen. His patience and understanding with the nights and weekends I spent mixing, shooting, and writing were greatly appreciated, and he gave me the confidence and support I needed the entire way.

I'm so grateful to my amazing friend Lydia, for pulling me out of a creative block and inspiring one of my favorite drinks in this book.

Special thanks to Mattel, my agent Clare, my editor Maria, and the rest of the publishing team for taking a chance on me.

Extra pets for my dog, Bogie. He kept me company for just about every second of this process, snoozing on the couch next to me as I wrote, following me around the kitchen as I tested out recipes, and only *occasionally* nudging my hand as I edited photos.

INDEX

ABOUT THE AUTHOR

Sharing food and drink is a way to show love. At least that's how Ginny Landt feels about it, from the start of her career as a candy scientist to the cocktail creator she is today (although she's still searching for the perfect espresso martini). Ginny lives in Chicago with her husband, Brandon, and their dog, Bogie, who has been featured in many of Ginny's posts on her cocktail Instagram @ginbeforebreakfast. Ginny grew up playing with Barbies with her cousins and would like to apologize to the Barbie whose hair she (unsuccessfully) tried to dye with ketchup.